I'M ONE
21ST CENTURY MODS
HORST A. FRIEDRICHS

PRESTEL
MUNICH · LONDON · NEW YORK

21ST CENTURY MODS
ROB BAILEY

What are twenty-first century Mods? Lovers of all things Mod, Sixties and beyond; those who can still chime with a genuine, contemporary echo of the past amid today's ill-defined Youthquake. People who share a true, devoted love of quality vintage and contemporary music, whether it be Jazz, Hammond, Boogaloo, Club Soul, Beat, R 'n' B, Garage, Psychedelia, Pop, Be-Bop, Freakbeat, Britpop, Rocksteady, Mod-Funk, Northern Soul. There are purists, who say that's nothing to do with Mod, but I think we're a broad church with a wealth of culture, references, influences, great music and style spanning almost five decades across all continents. Why would you do anything else?

I first discovered Mod at school in Kent, Southeast England. Tons of kids in my year, and particularly the two years above me, were Mods. Those who were old enough would drive their Vespas and Lambrettas into school, which I thought was the essence of cool.

First and foremost for me, it has always been about the music. I first got interested through Two Tone and Mod revival bands of the day, especially The Jam who stood head and tails above the rest; and listening to my mum and dad's old Motown records and British Rhythm & Blues and Pop groups like The Animals, The Who, The Rolling Stones and The Small Faces. Then, I bought the first Kent albums, the London based Rhythm and Soul label – I was blown away. So, by the time we all started going to weekenders and clubs we had already started our induction into the more sophisticated and stylish Mod sounds.

The Mod music of the late seventies and early eighties wasn't really our bag any more. We were all growing out of it and obsessed with more authentic sounds. At the Mod weekends we attended, we found ourselves bored by the Two Tone and Powerpop bands and were always waiting for the DJs to come on and spin their 45's. The only live band I really dug were local heroes, The Prisoners, who had sadly split by the mid-eighties. I never watched bands at this point until The Dukes, who metamorphosed into The Clique, came along playing the kind of R&B and Soul sounds we liked in an authentic way like The High Numbers. They were important because they gave kids of my age, who were just discovering the original Mod scene, a band we could identify with. They were exciting, fresh and doing something completely different from the other bands of the period and looked as cool as fuck too. My own musical tastes have broadened over time, but Mod has always been and always will be about good taste.

Paul Weller made his solo comeback in the 90s, Detour Records was born and so were The Untouchables. Without Weller, there would have been no recognisable Mod scene in the 80s, 90s or even now. The Untouchables started with a new decade and at a fairly low point for the Mod scene. The London scene in particular was looking for something new, which reflected its particular urban interests. So, we started doing our own weekenders and events that were much more suited to our tastes. The Aardvarks who we discovered through following The Clique both played a pivotal role in that change as both the Sixties scene and the Mod scene discovered one another and, with dwindling interests in both camps, The Untouchables created something fresh and new by fusing the two things together, so we had a decent scene.

Detour did an amazing job bringing out records from the crop of exciting bands of that era, creating an even bigger buzz around what we were doing. European labels including Twist, Animal Records and Screaming Apple also played their part in the rebirth. We were the hardcore Mods who heralded the dawn of the Britpop era. Mainstream acts like Blur, Oasis and Pulp brought intelligent Sixties-influenced sounds back into the pop charts, thereby generating interest for a new generation, eager to discover the roots for themselves.

Mod is a lifestyle and, like all Mods, I'm into my clothes as well as my music. From an early age, as a teenager I was going to The Cavern on Carnaby Street and the other shops along there. I went to second-hand clothes markets trying to find the finest threads. We were dressing fairly well when we were only fourteen. We always

wanted to look smart but on a limited budget as a teenager. Then we started taking regular forays into London. When I went to Sneakers for the first time, I just thought to myself, 'Fuckin hell! I need to go home, work hard, earn some money and come back with some decent togs.' The music and people were amazing it was a real eye opener.

There was Alan H, Val Palmer, Ian Jackson, Paul Newman – all these faces who were a few years older than our crew and were the benchmark. I remember the older kids at school were coming in, at that time it was the early eighties, wearing £50 crombies – back when fifty quid was a fucking hell of a lot of money. You're looking and thinking, 'Where the fuck did you get that?', but they got it. Mods have always been very resourceful. So we all went back, dusted our young selves down, did our homework, worked our arses off and came back, smarter, smoother, suave and looking every inch the part. Mod is about taking pride in your appearance, where you live might be poor, but that doesn't mean that when you hit the street you have to reflect that by looking like a slob.

The great thing is that you can be a Mod at any age, because it's about good taste and being smart. You don't look ridiculous like a Teddy Boy might at the age of forty or fifty. You can always be a Mod. Maybe you're not going to wear your candy-striped hipsters as a forty-year-old man, that's a young man's game, but you can look great at forty. Other Mods are going to know you're a Mod. Other people in the street aren't going to pick on you because you don't look like a clown.

The New Untouchables were formed in London in the Autumn of 1997 at the apex of the Britpop movement. People who had become interested in the music through this very modern genre often found themselves interested in Mod too. The time was ripe for a new surge of Mods and 1960s fans and The New Untouchables were there to encourage them with newsletters, club nights, national and international weekenders, scooter runs, retro markets and record fairs.

We're not all about slavishly copying what has gone before. Mod is a continually evolving, living, worthwhile cultural landscape, that still provides a space today for those who find what the mainstream has to offer as dull, crude, shoddy, lazy, aggressive and air-headed. Through The New Untouchables' many events and clubs, gigs and happenings, all around the world, we have built a fun-filled space for those seeking self-expression within a strong and peerless tradition of hedonistic pleasures, rare sounds, stunning visuals and new sensations.

While the Mod thing was born in England and is a uniquely British phenomenon, the scene is truly worldwide now. We have embraced modern technology with the internet and taken advantage of cheap air travel and we now have brothers and sisters from all over the world attending our events and keeping in touch through our own social networks. This makes new ideas and friendships possible and the scene even more vibrant and alive. Since then, we have become an international organisation promoting Mod and Sixties culture worldwide through the website, magazine and events held in Spain or Italy, featuring bands from Germany, Australia, Japan and the United States, in association with other like-minded organizations from around the globe, run by people equally as passionate about this wonderful lifestyle.

This book charts the progress of The New Untouchables over the last decade or so. One day, this professional German photographer called me up. He'd seen an advert in Carnaby Street, something about a meeting in Scarborough and wanted to come along and take some photographs. So I gave him the details and he came with us and that's how it all started to be properly documented.

Having the book is like having the Le Beat Bespoke compilation albums we do. It's great to have a body of work. Having this visual record is brilliant. The good thing about Horst (A. Friedrichs) is that he understood the aesthetics of it from the outset. He came along with the group. He's a nice guy – polite, fun and sociable. People took to him, he wasn't intrusive. He's made a lot of friendships with the people along the way and they've been happy to collaborate with him. As a result, he's got some amazing stuff.

Today's faces have seen the book and everyone loves it. There have been books on the Mod Revival, and Sixties stuff has been done to death, but this book brings the whole thing bang up-to-date. This is the modern Mod story.

Rob Bailey was in conversation with Paolo Hewitt, London, 2009.

A REAL MOD DOES NOT CHOOSE TO BE A MOD, THEY DISCOVER THAT THEY ARE A MOD. IT IS NOT JUST A FASHION STATEMENT; IT IS THE WAY YOU FEEL AND ACT AND EXPRESS YOURSELF. MOD IS IN THE SOUL.

AMY

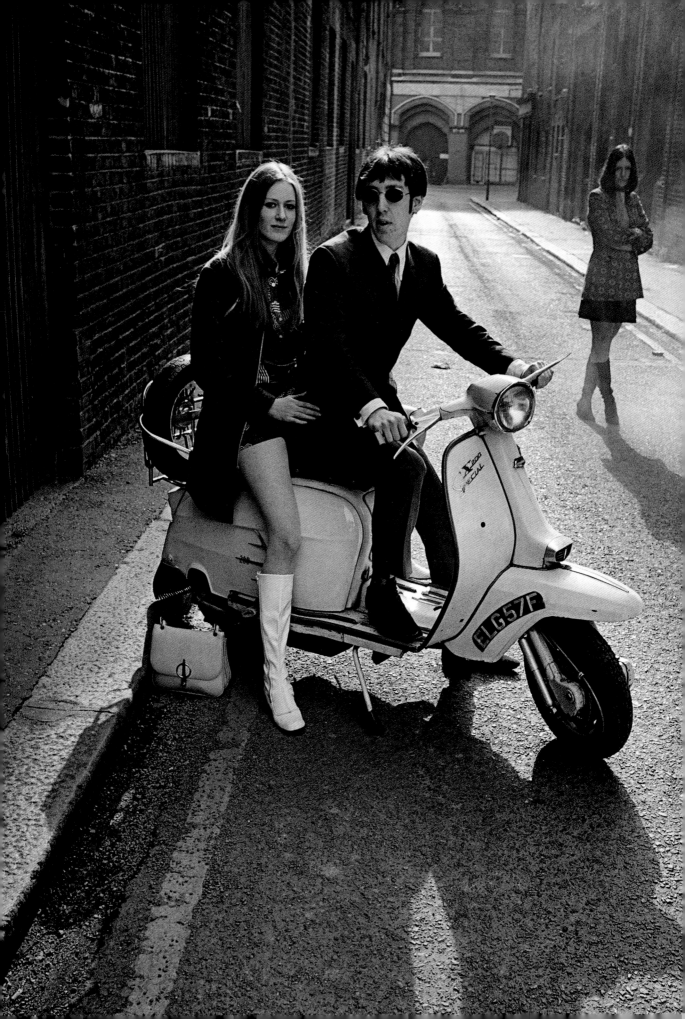

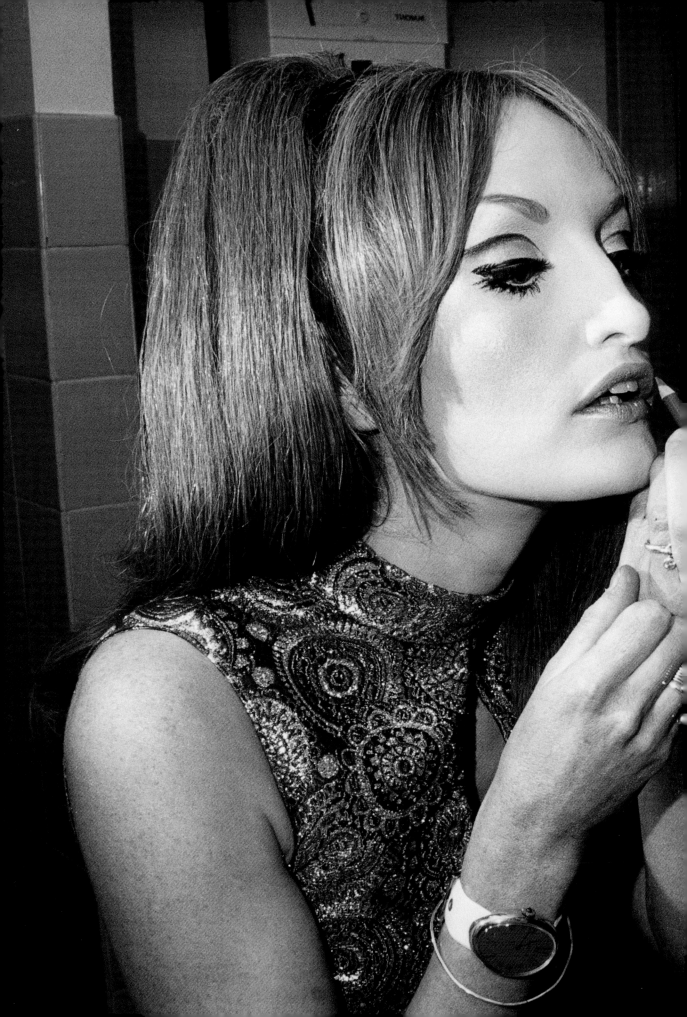

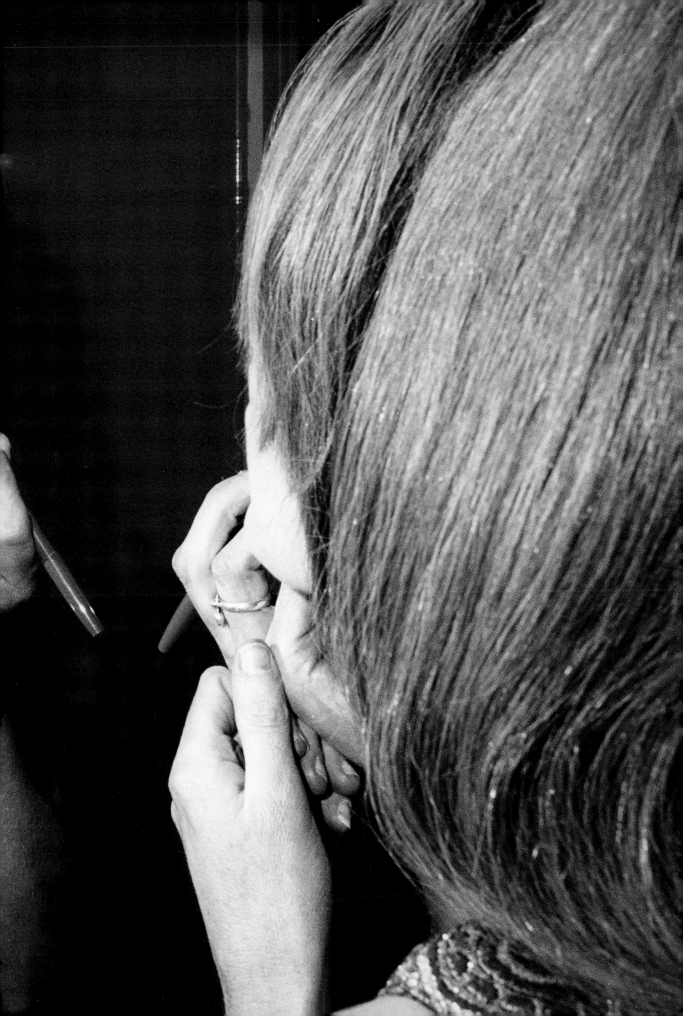

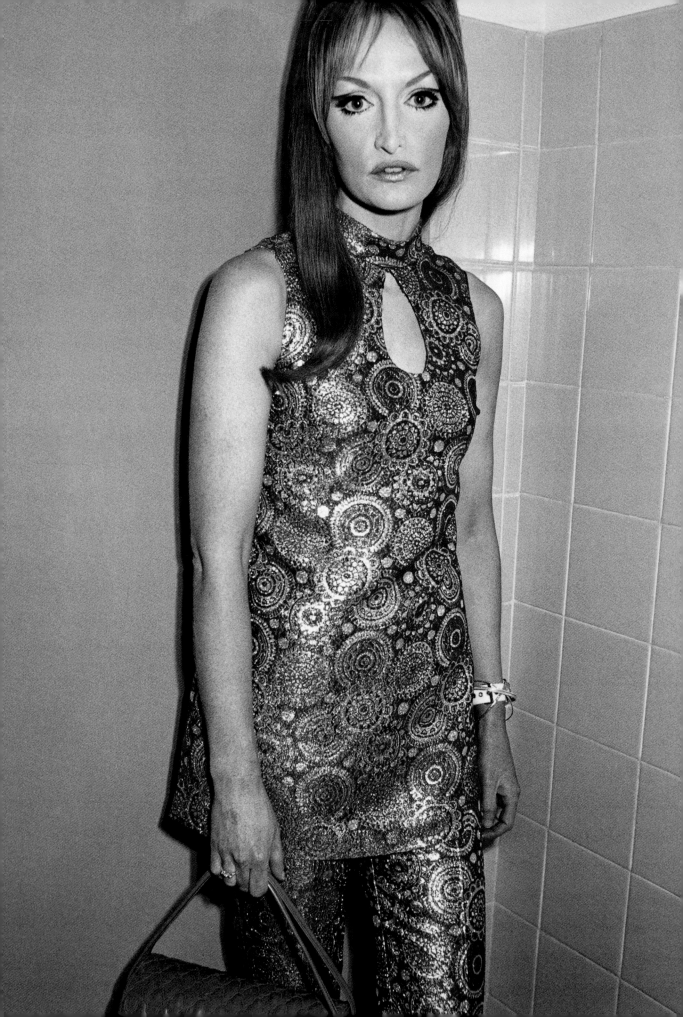

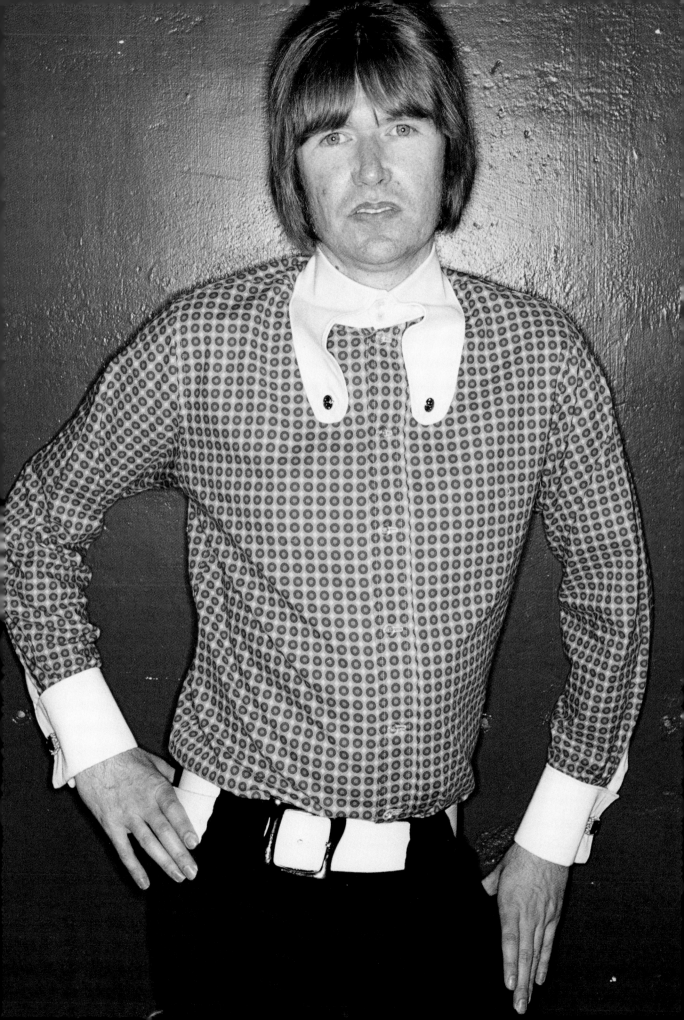

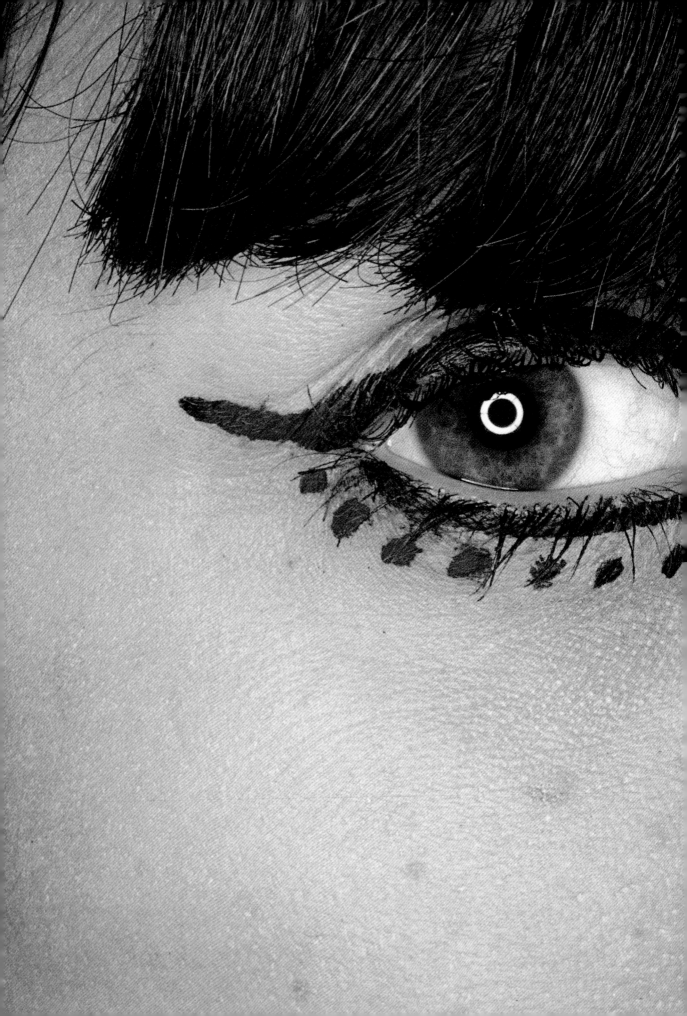

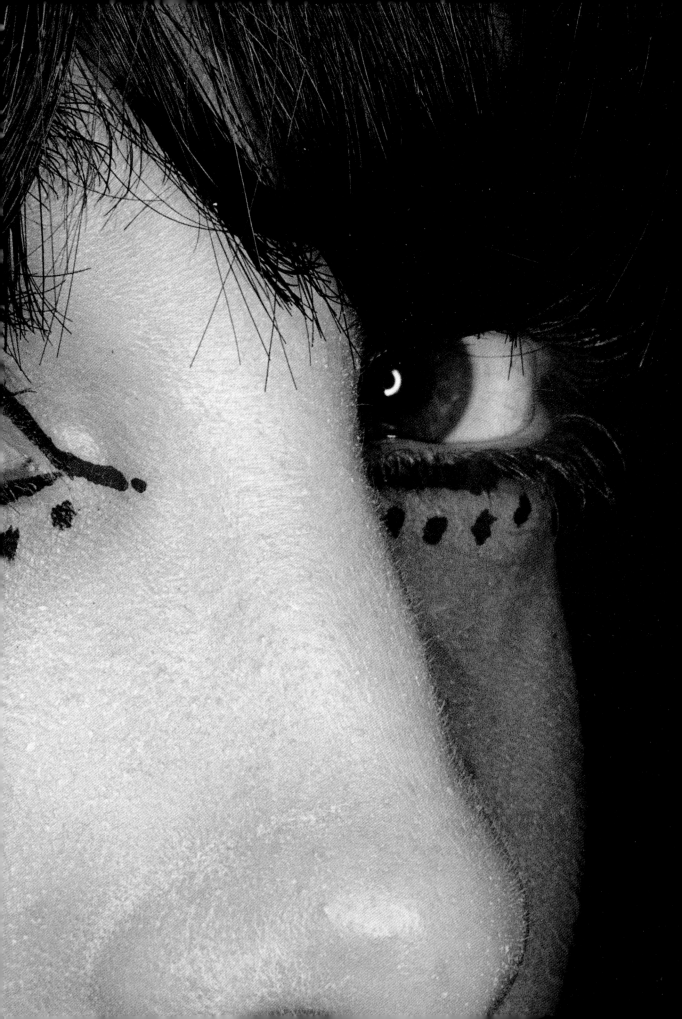

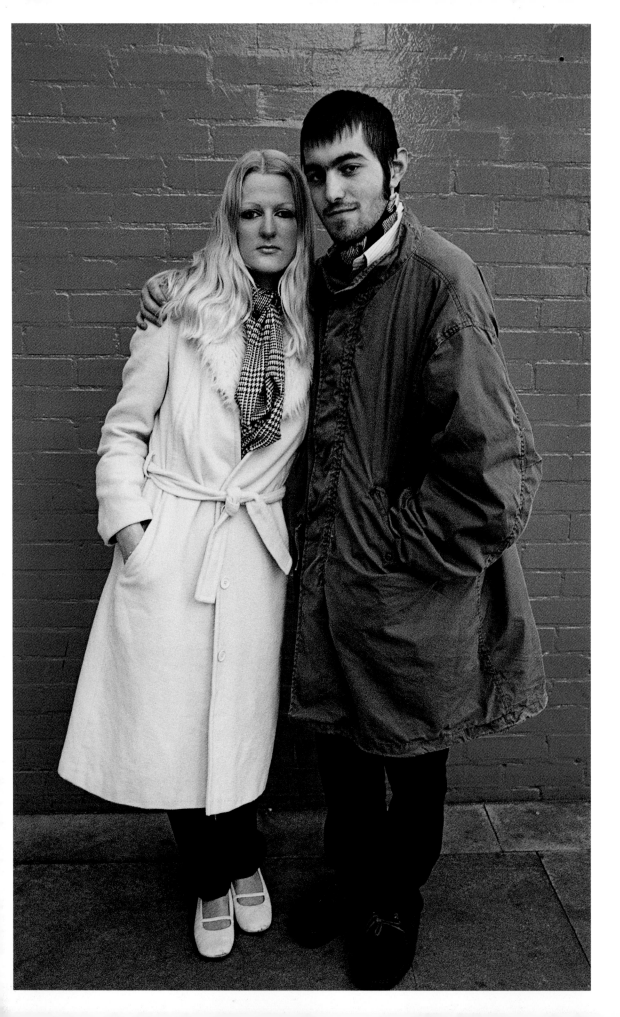

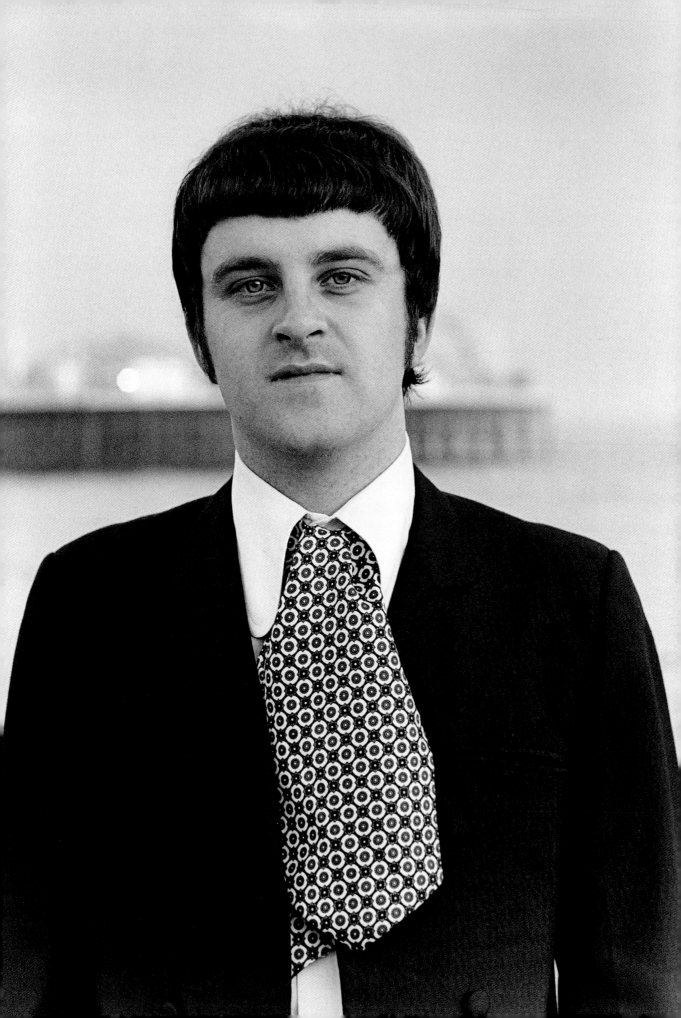

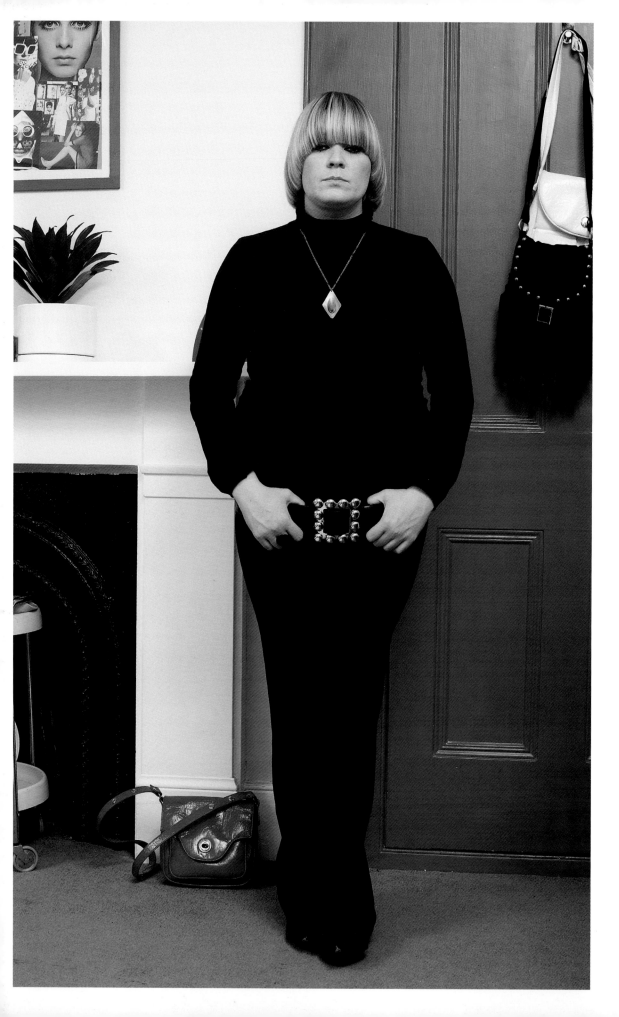

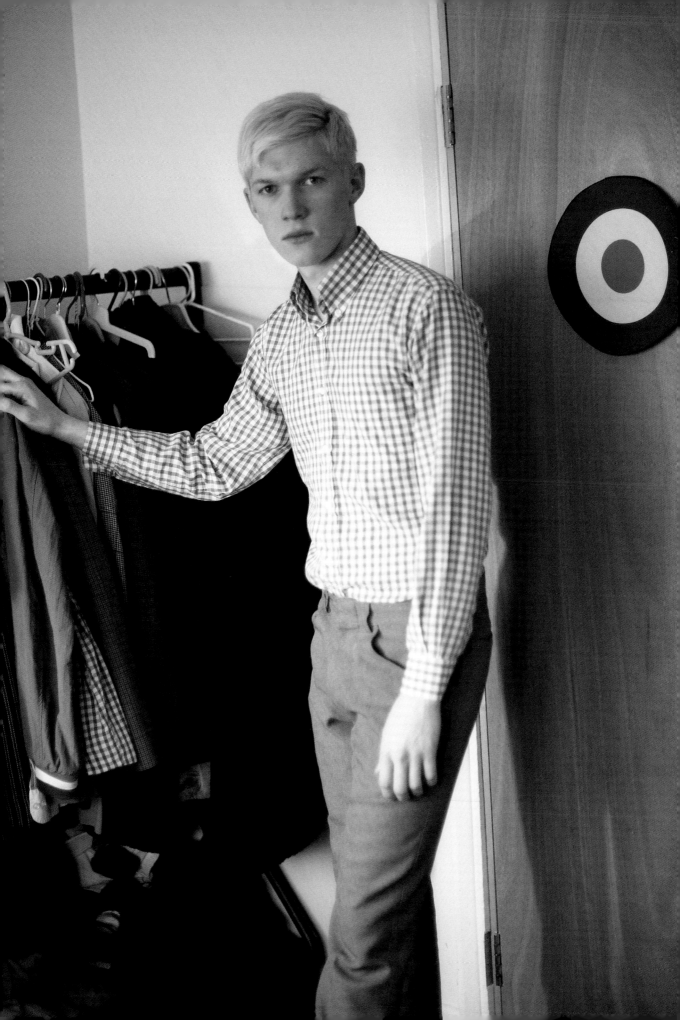

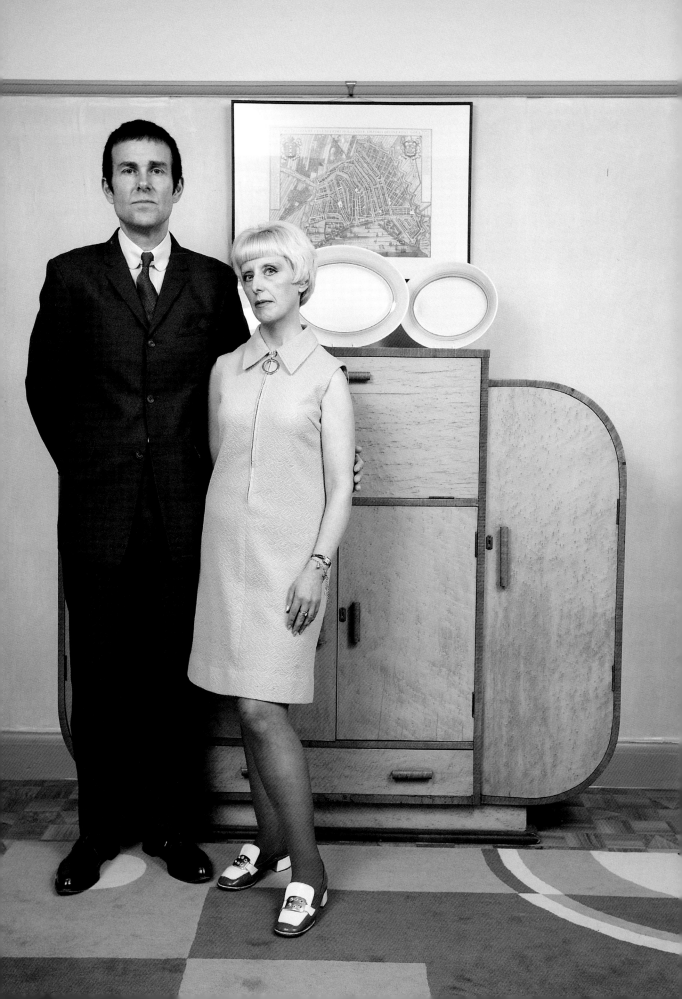

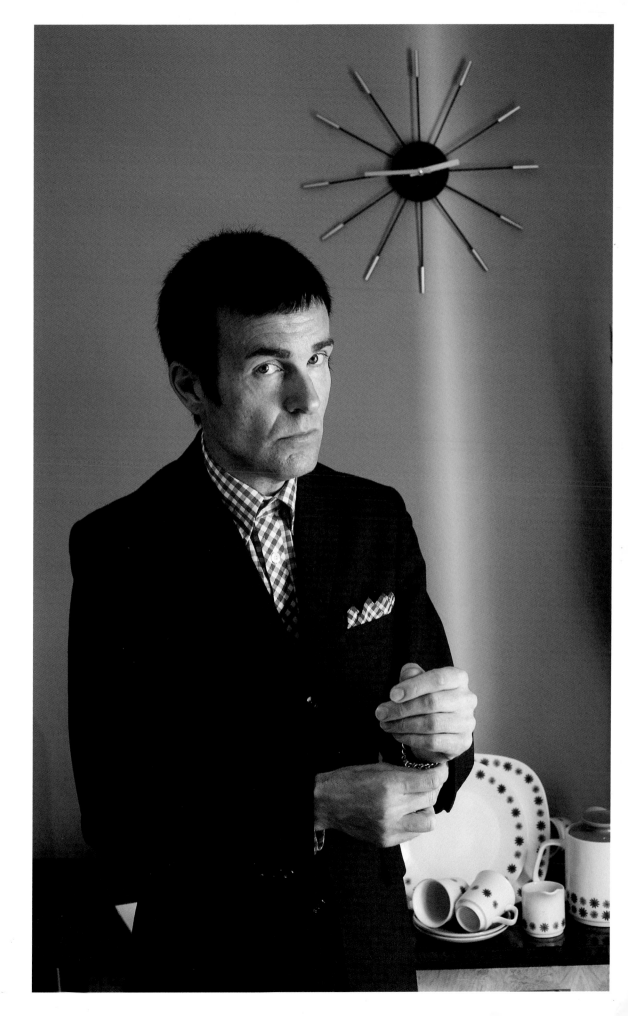

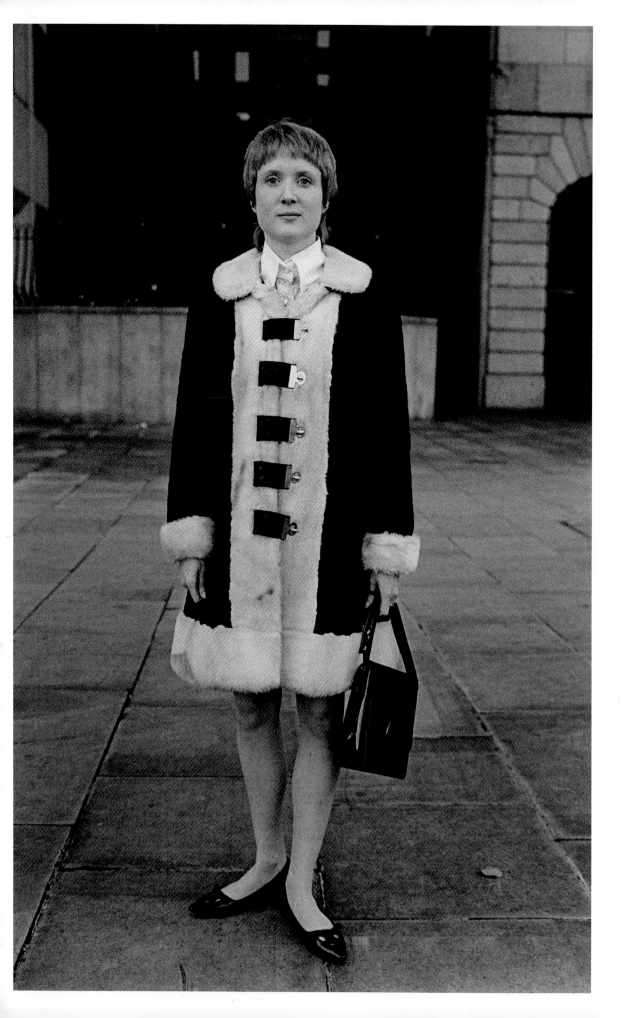

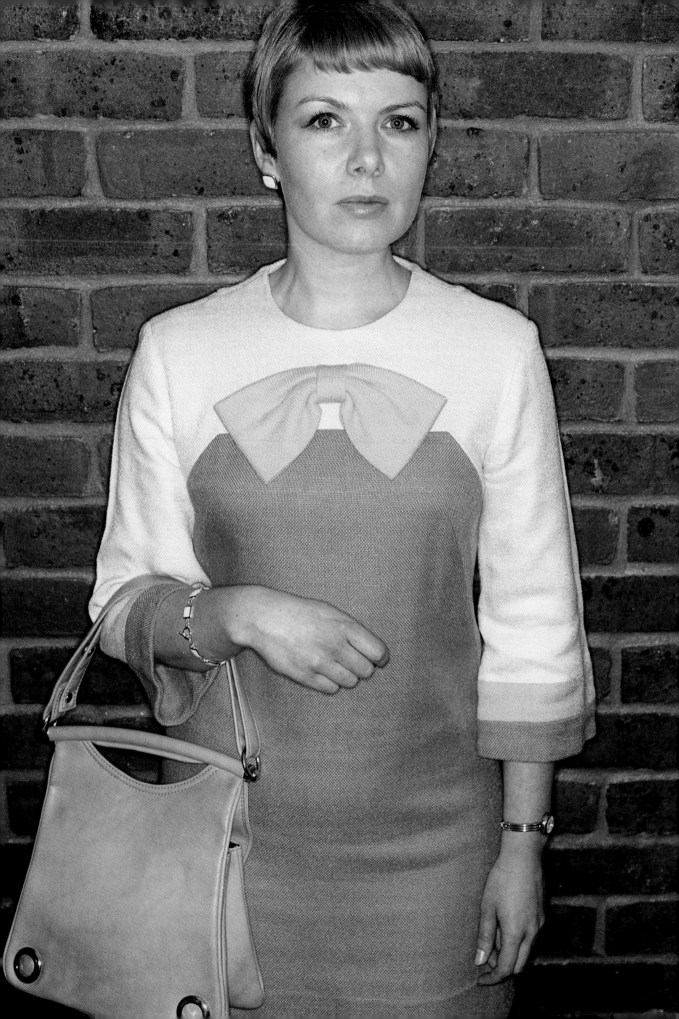

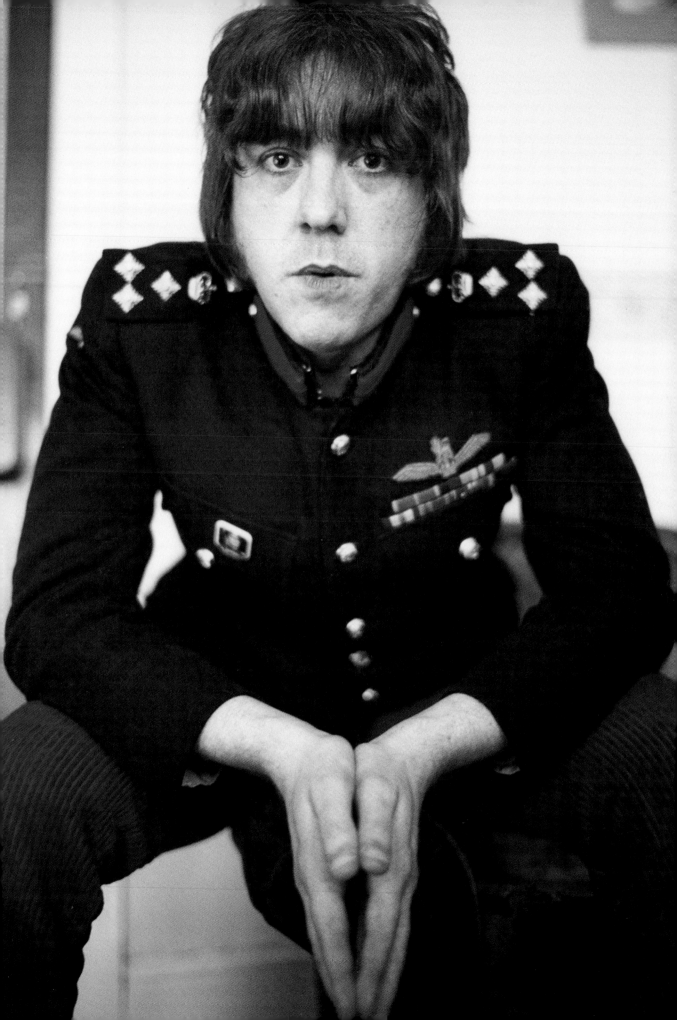

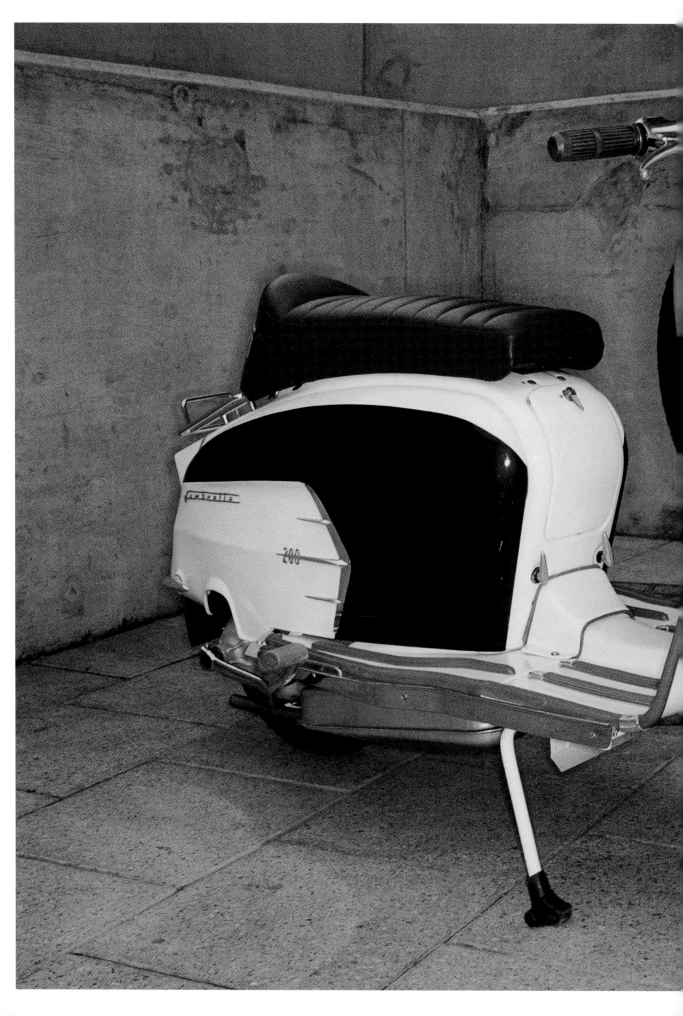

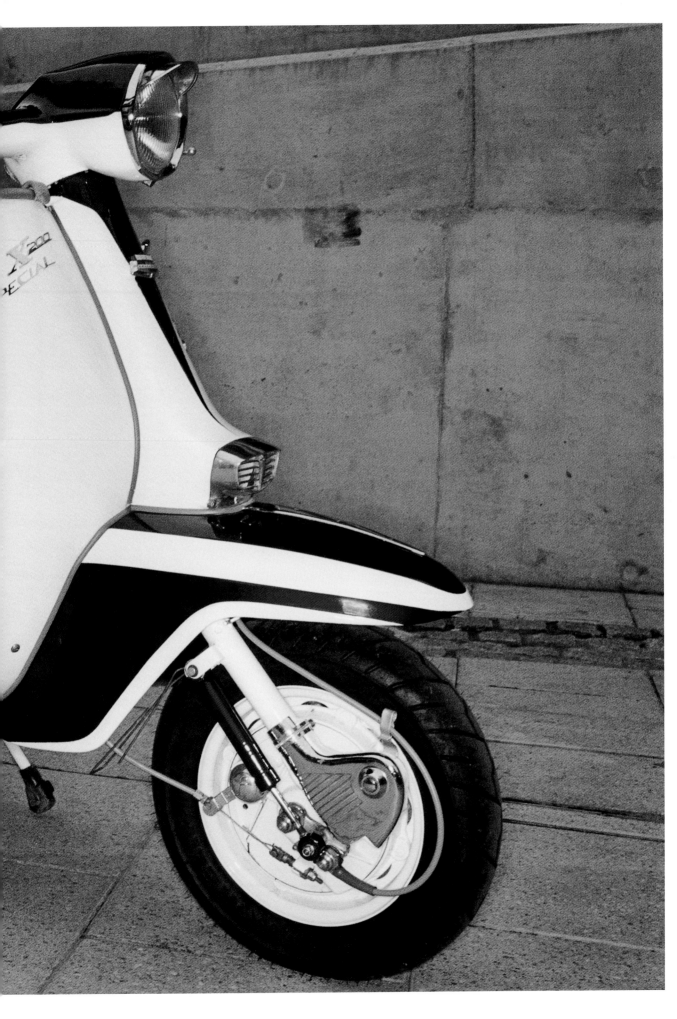

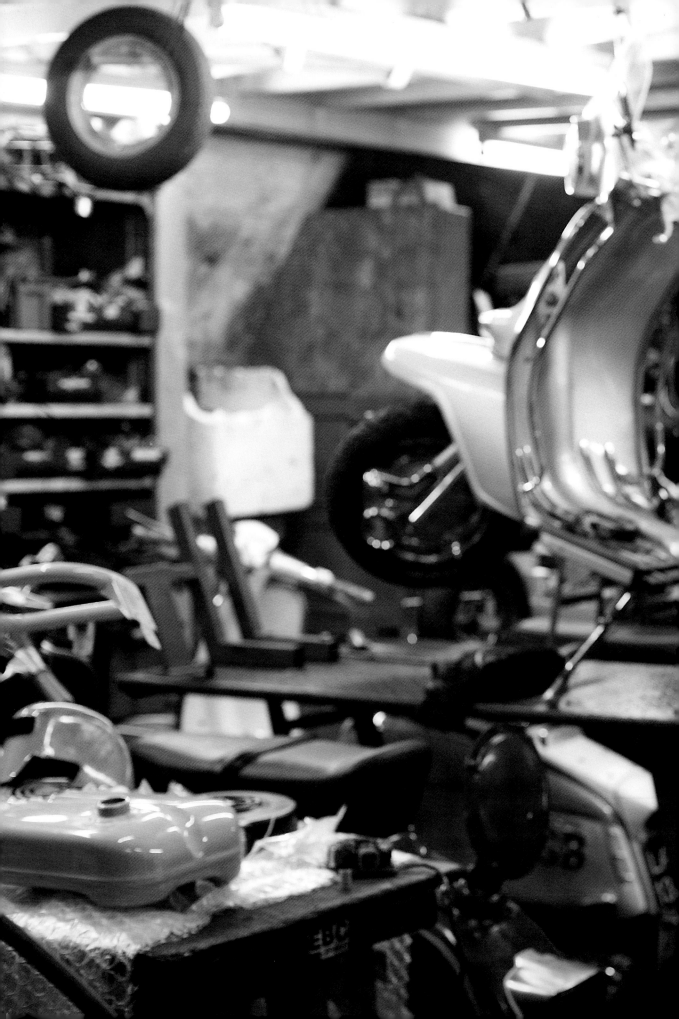

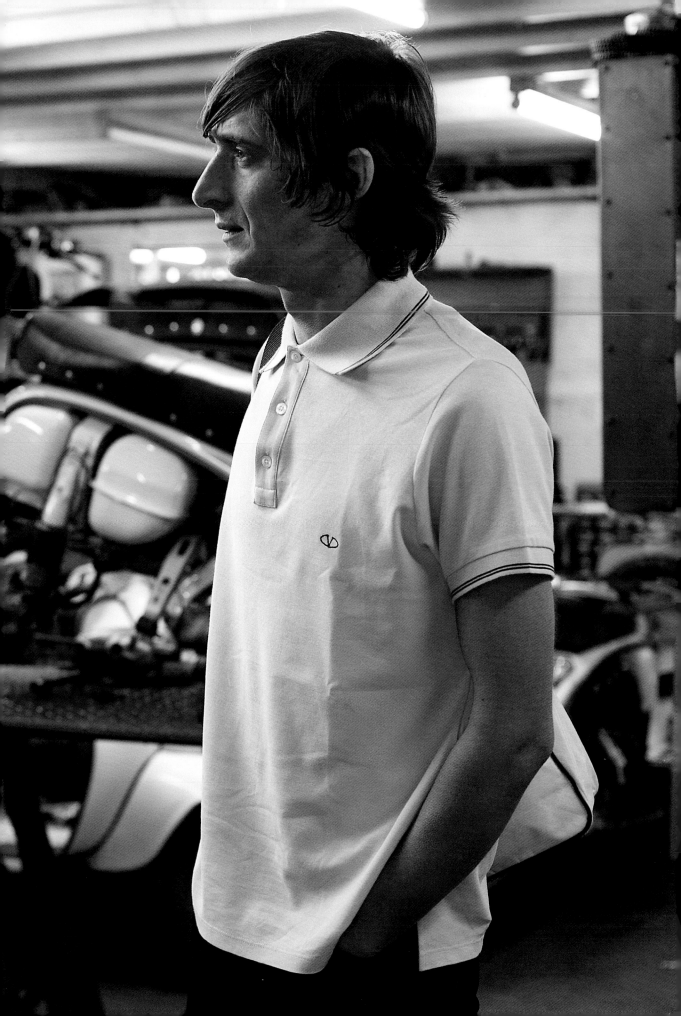

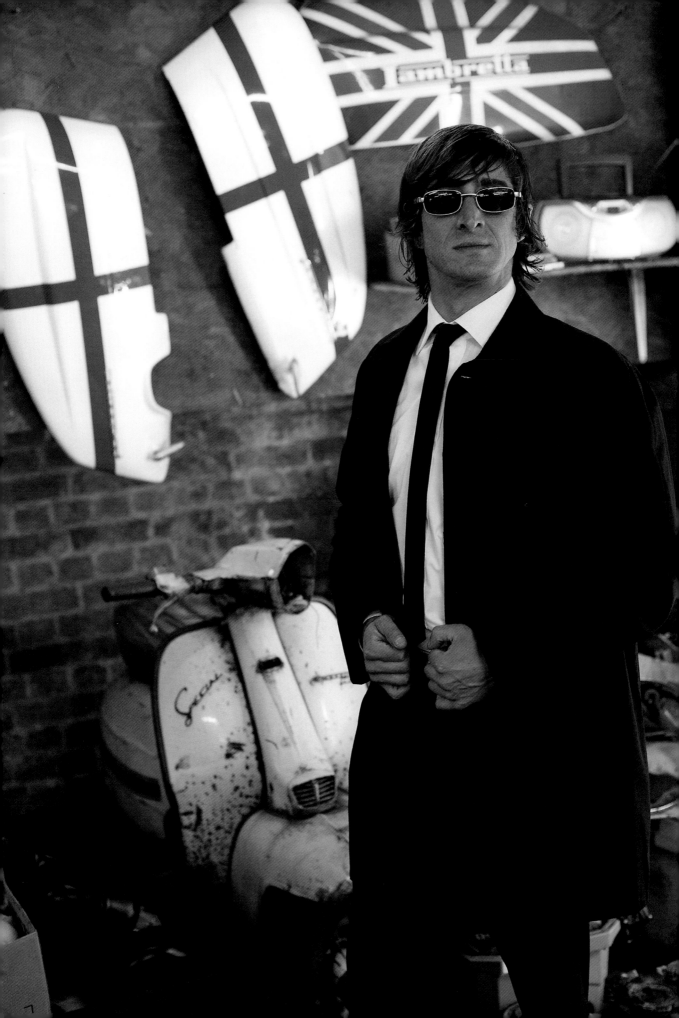

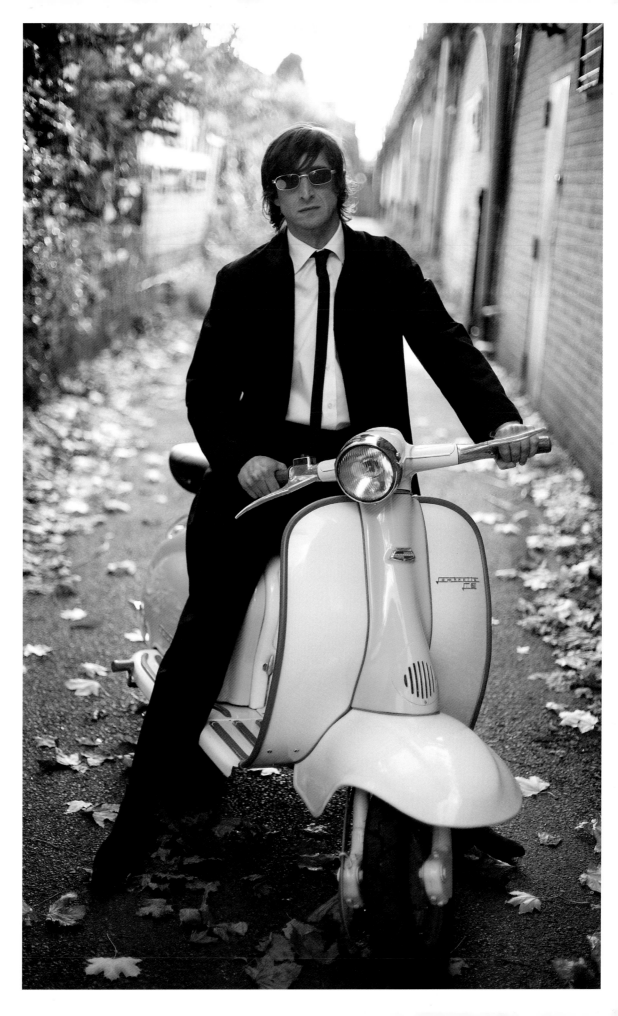

FAVOURITE MOD TRANSPORT?
OBVIOUSLY, THE SCOOTER –
ICONIC, ITALIAN ENGINEERING. IT MAY
NOT BE THE MOST RELIABLE AT TIMES,
BUT WHEN IT IS, IT IS THE BEST WAY TO
GET AROUND. AGAIN, IT IS TIMELESS AND
THE STYLE IS IMPECCABLE.
THE THING THAT MAKES THEM SO
AMAZING IS THAT YOU CAN MAKE IT
YOUR OWN: ADD ACCESSORIES; MAKE
THEM DIFFERENT COLOURS;
OR TUNE THEM; WHATEVER YOU DO,
THERE IS ONLY EVER GOING TO BE ONE!
SCOTT

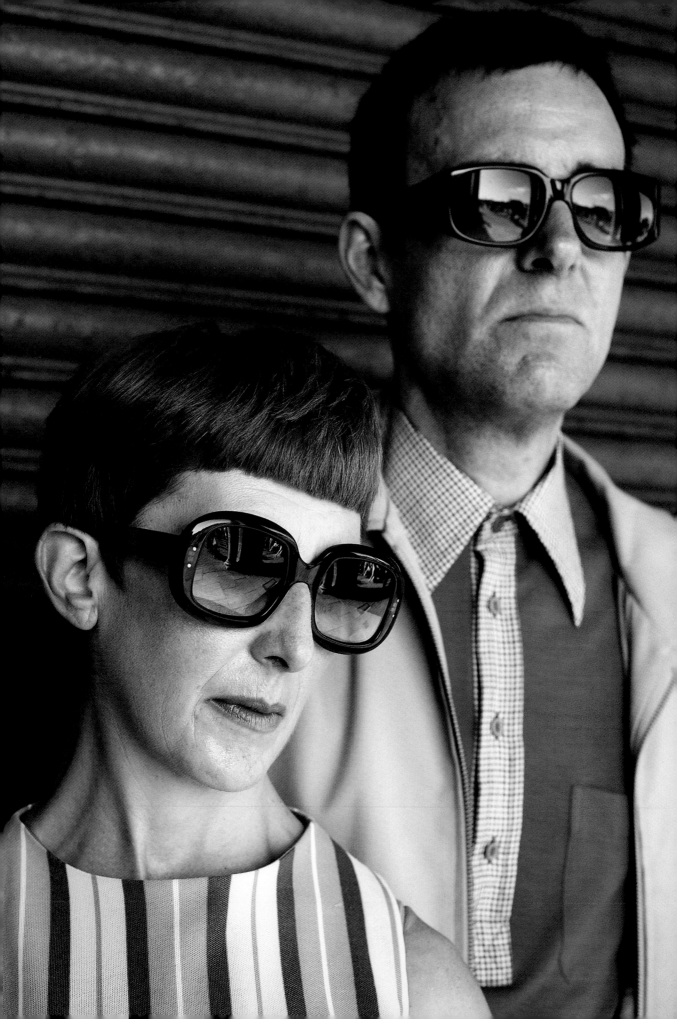

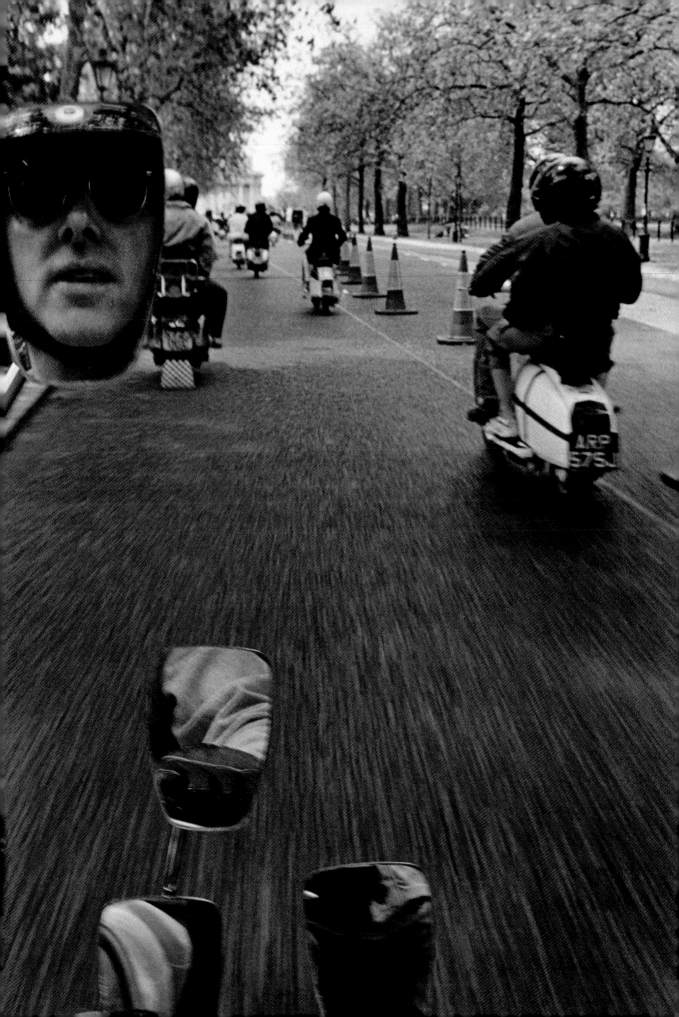

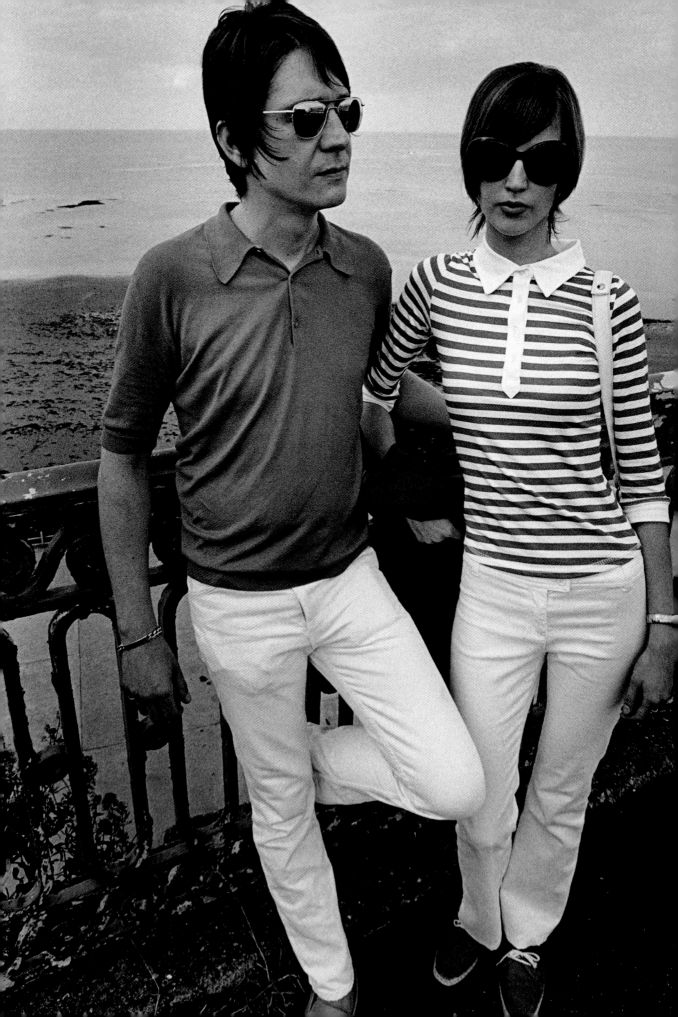

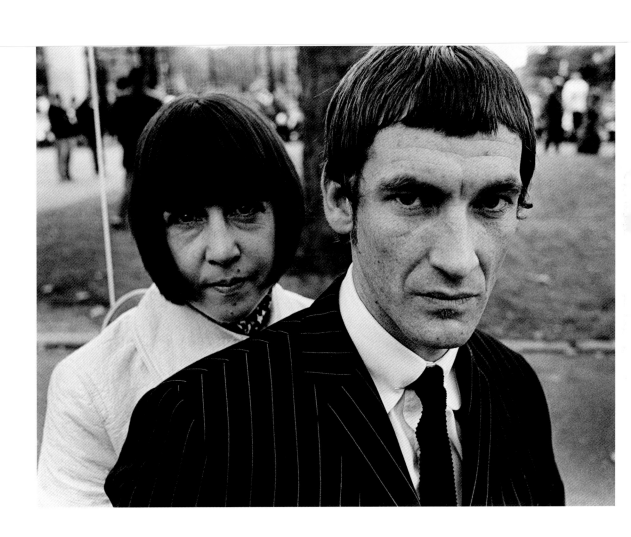

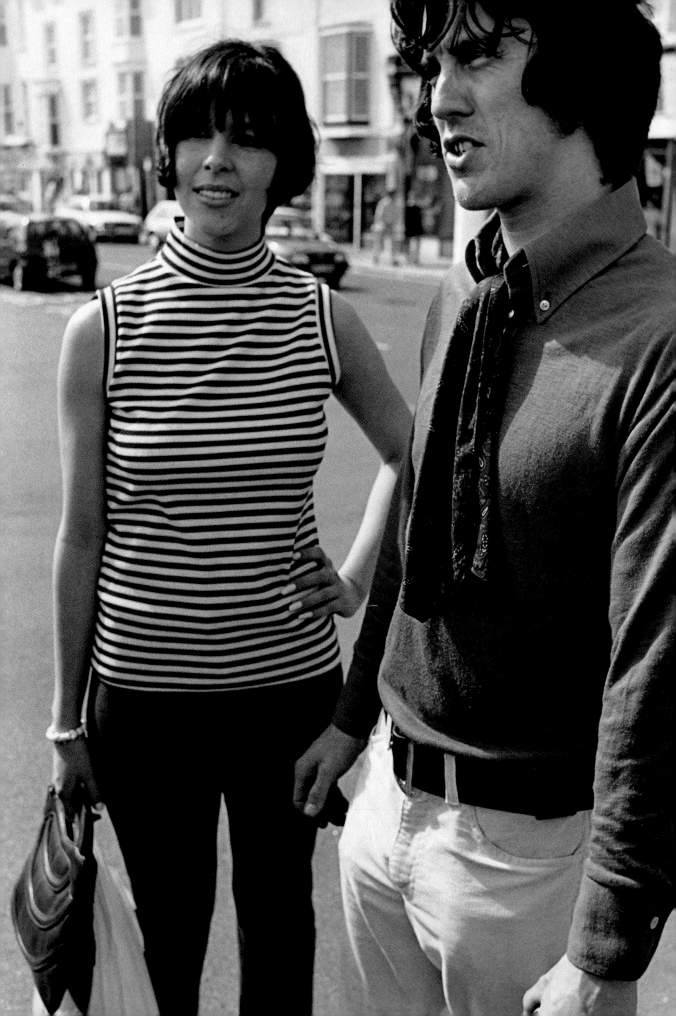

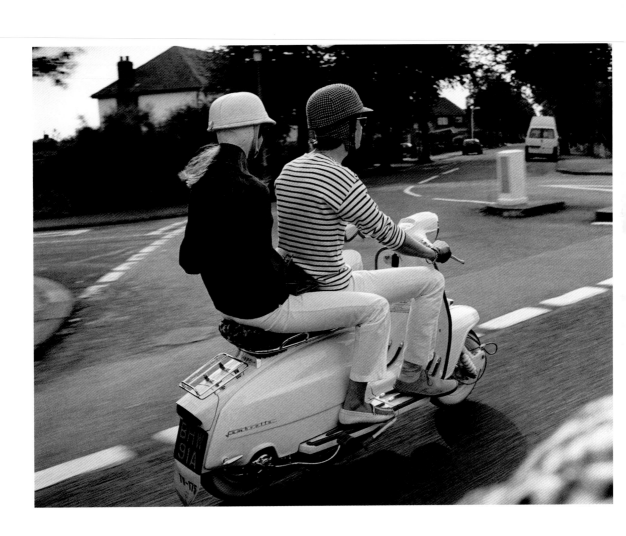

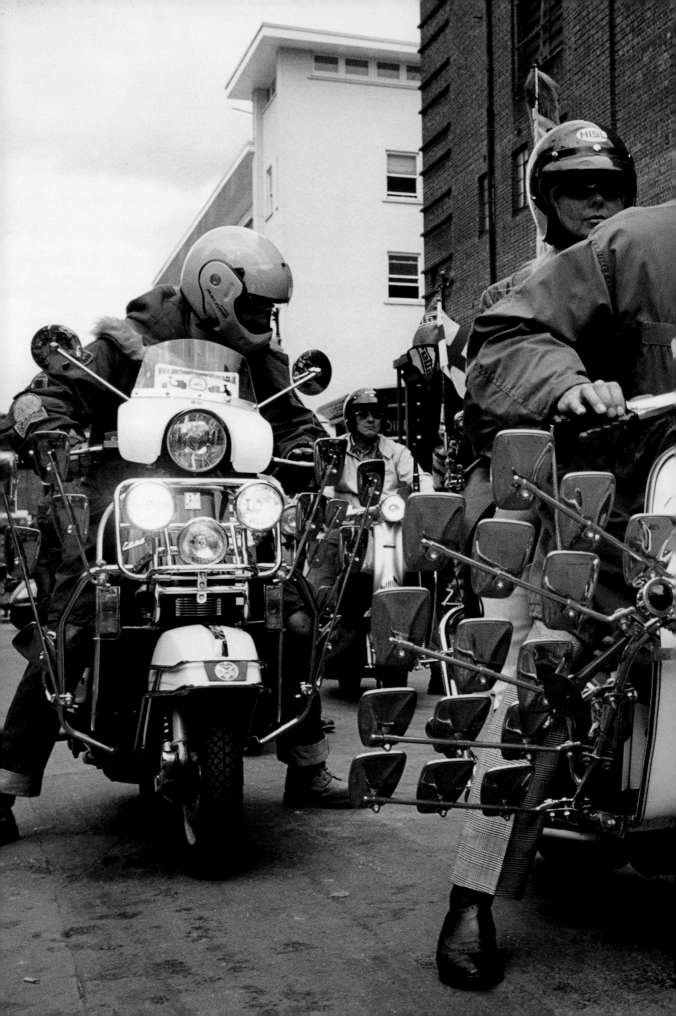

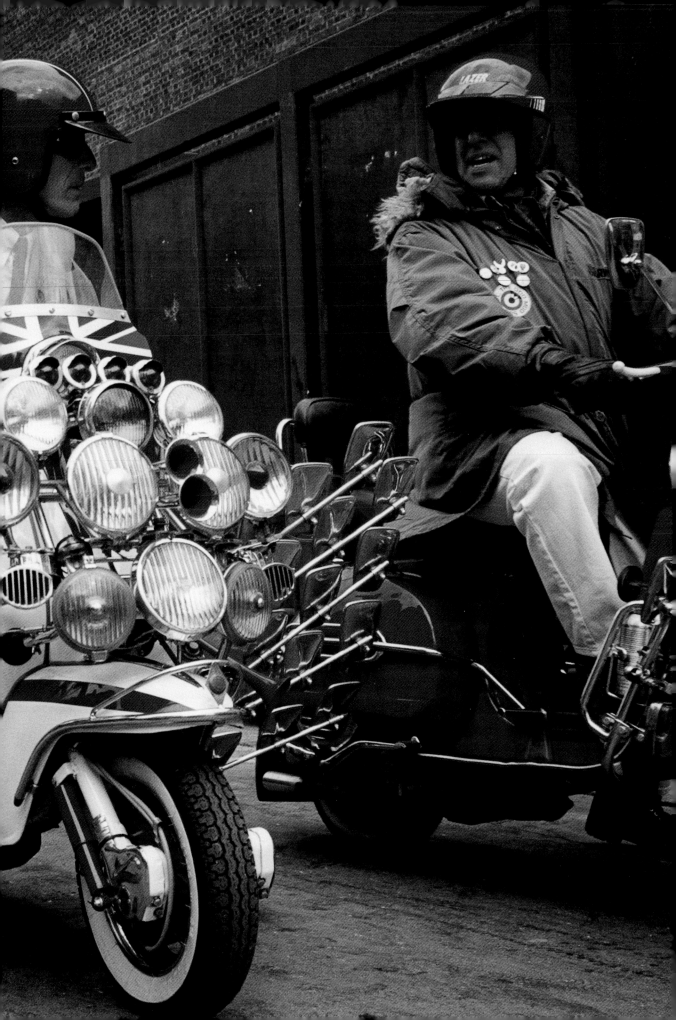

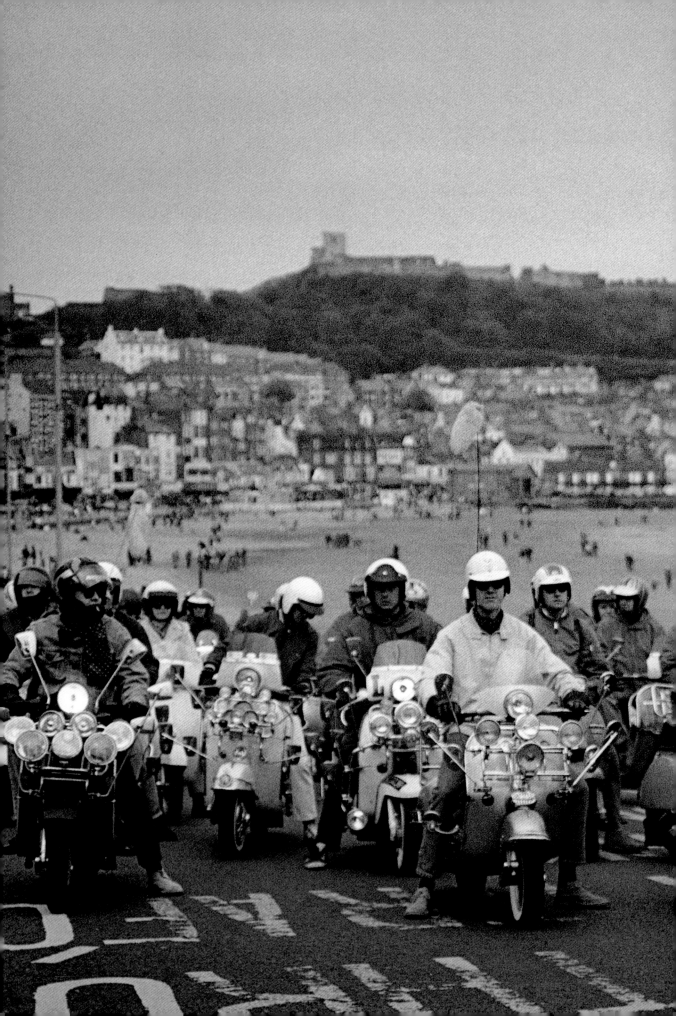

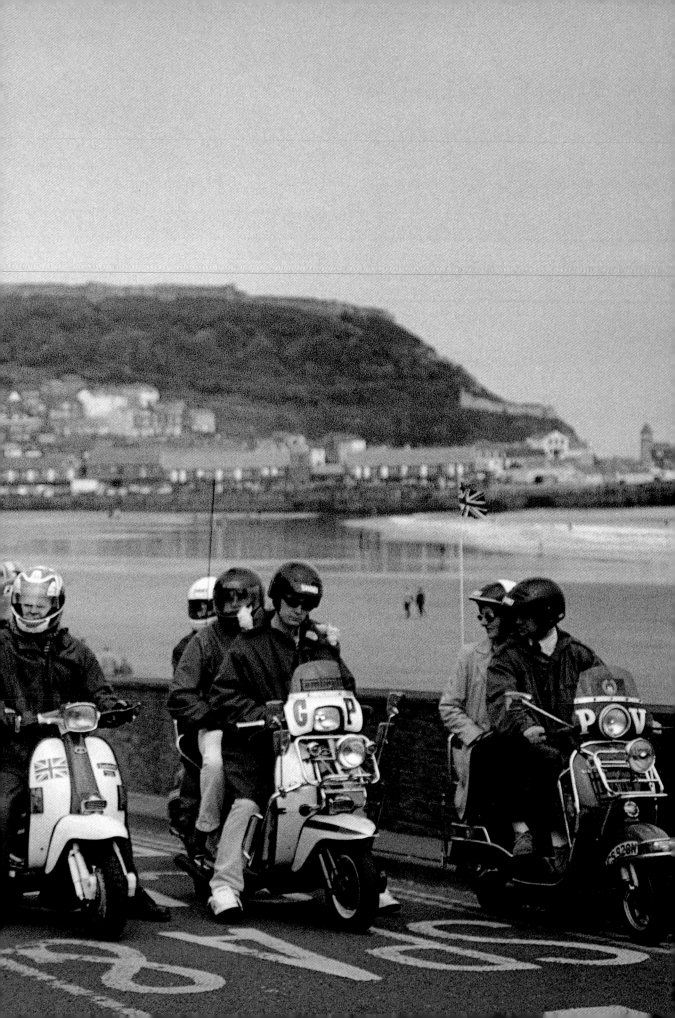

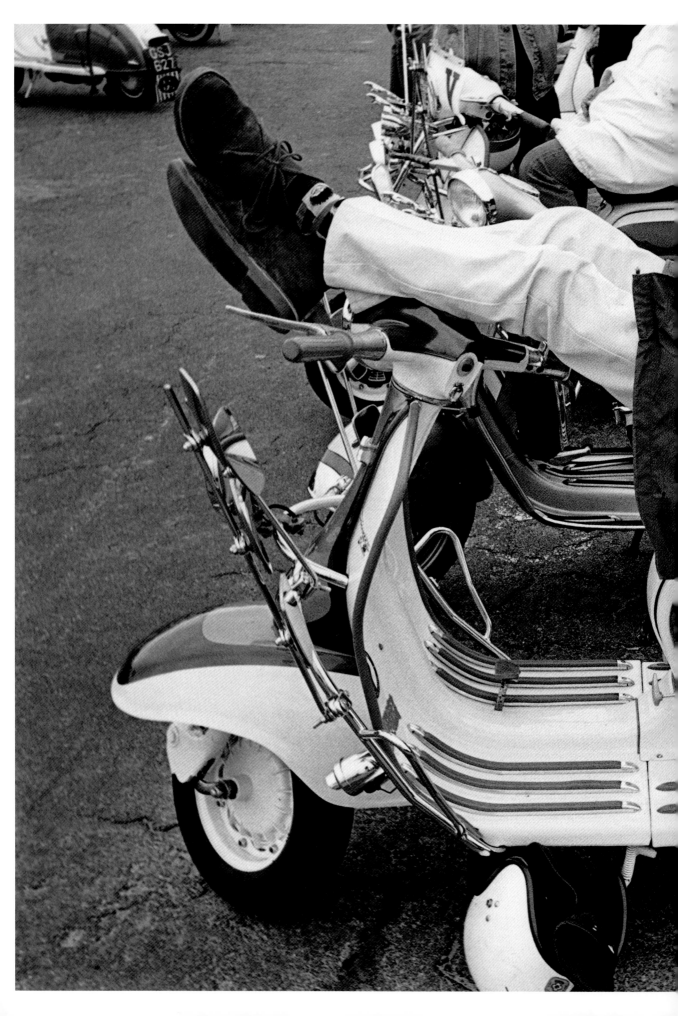

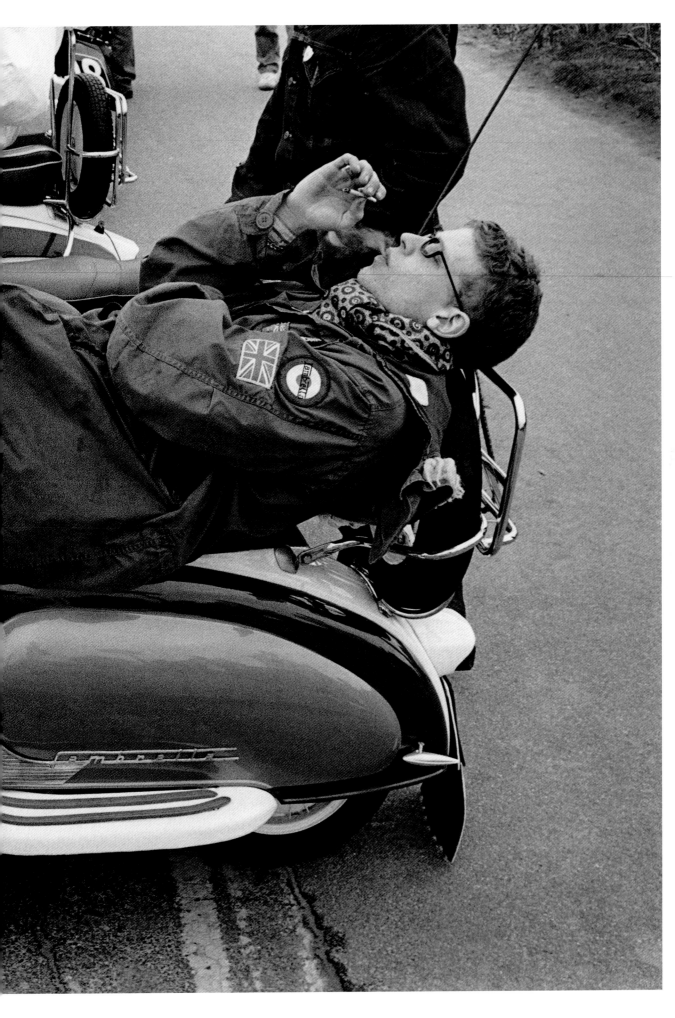

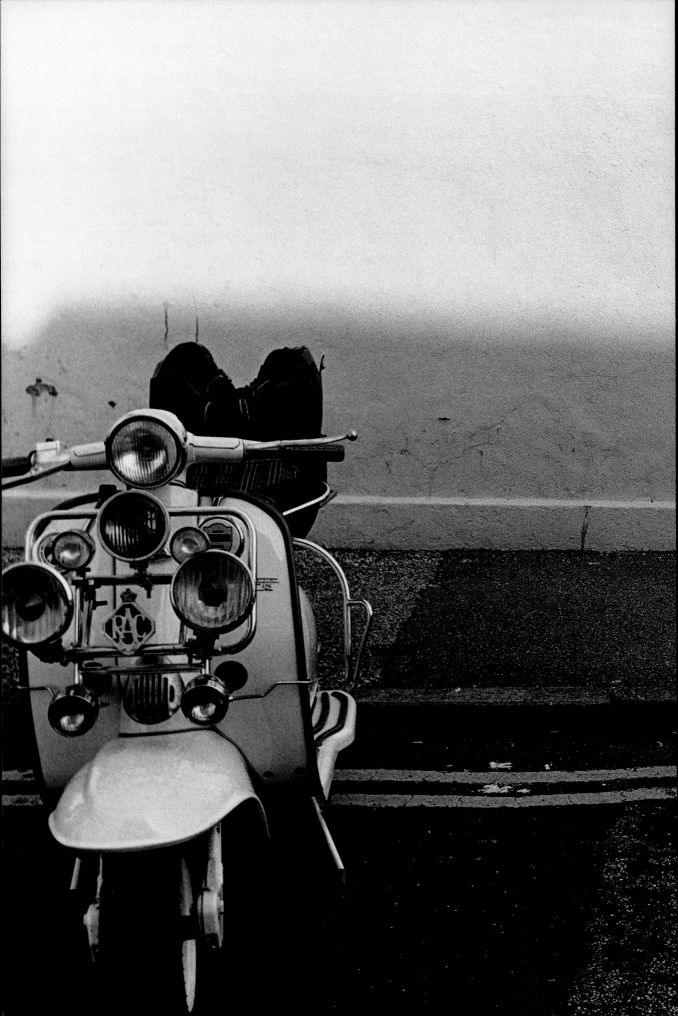

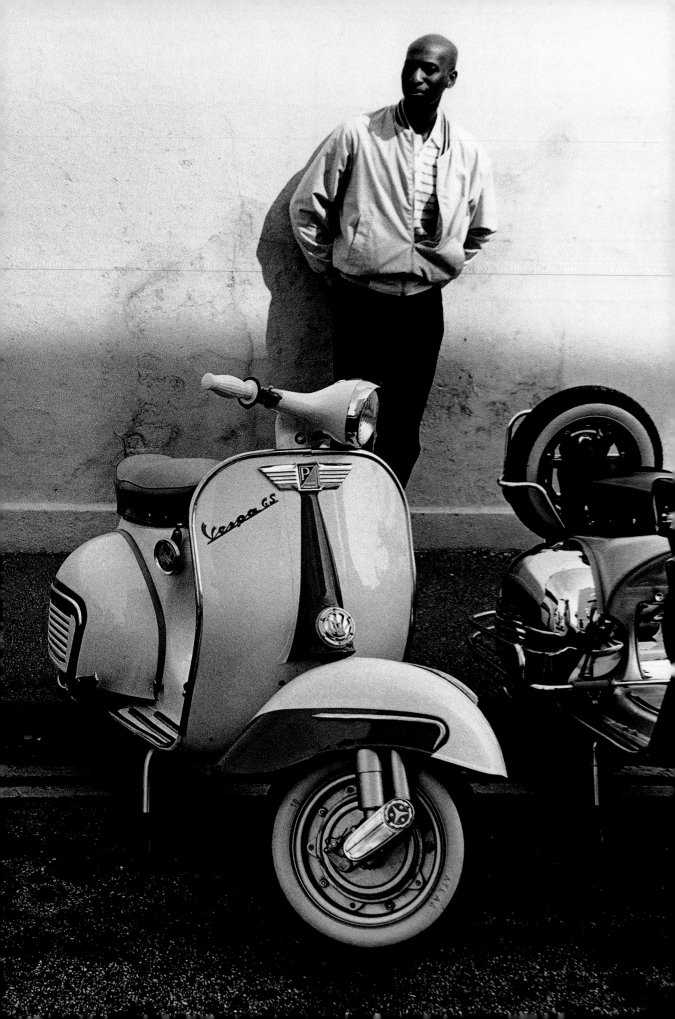

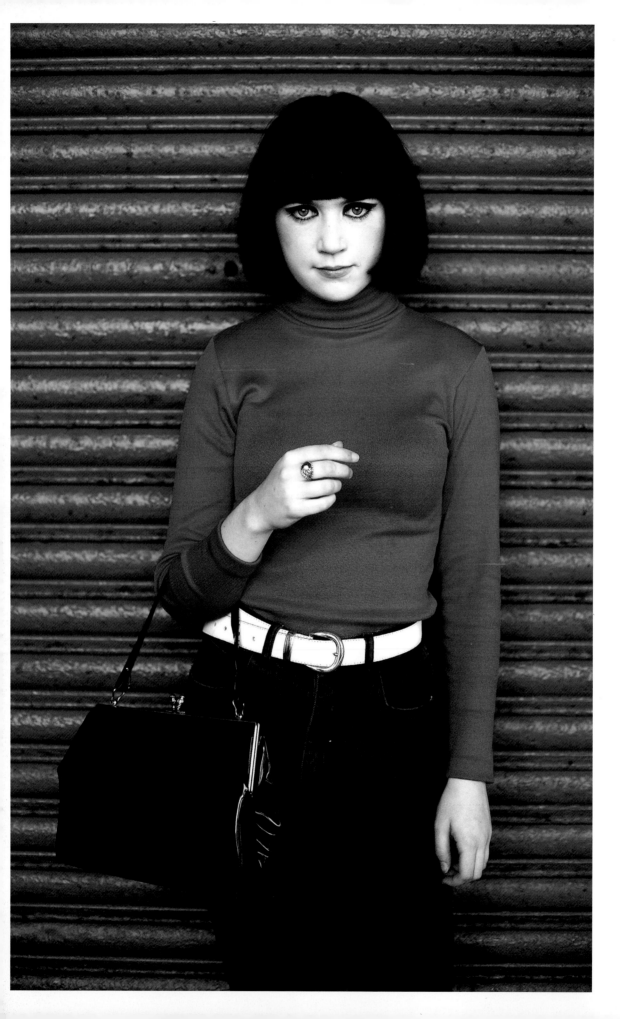

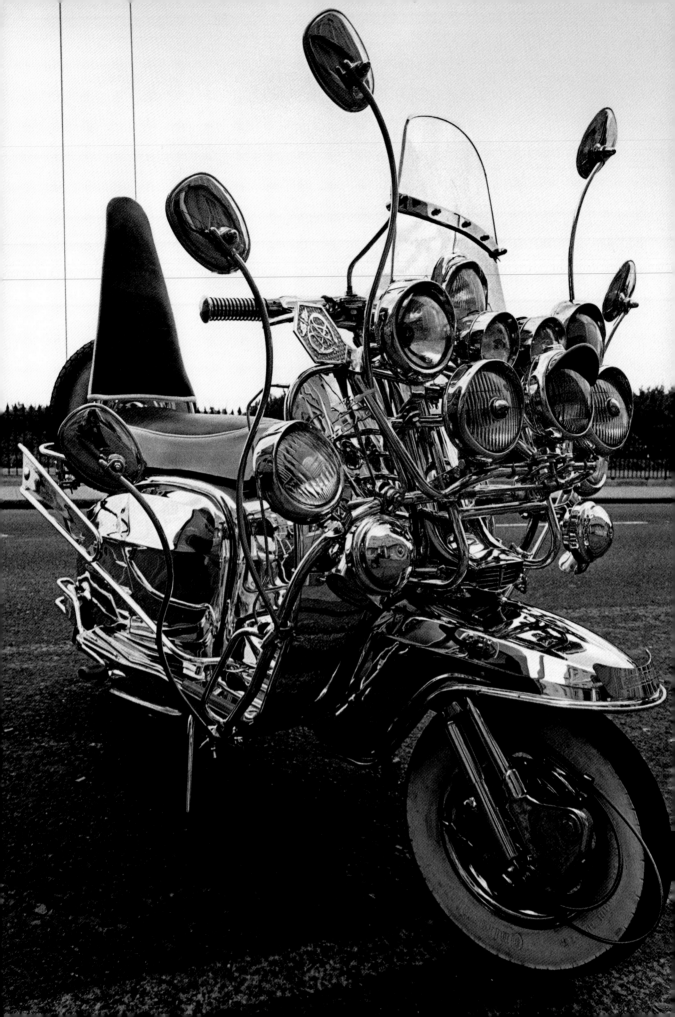

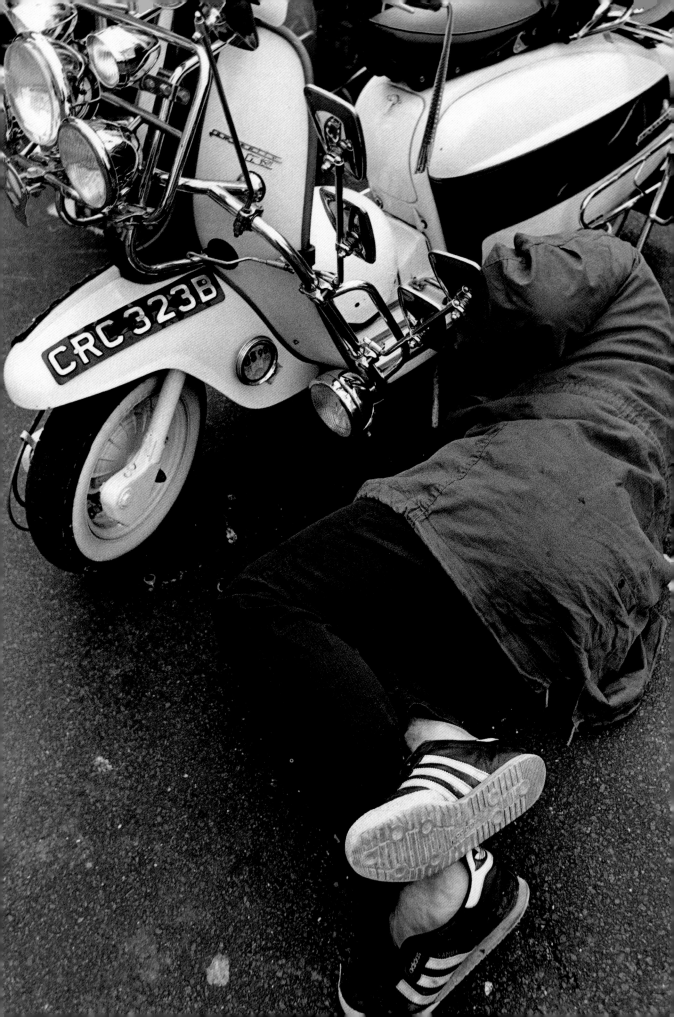

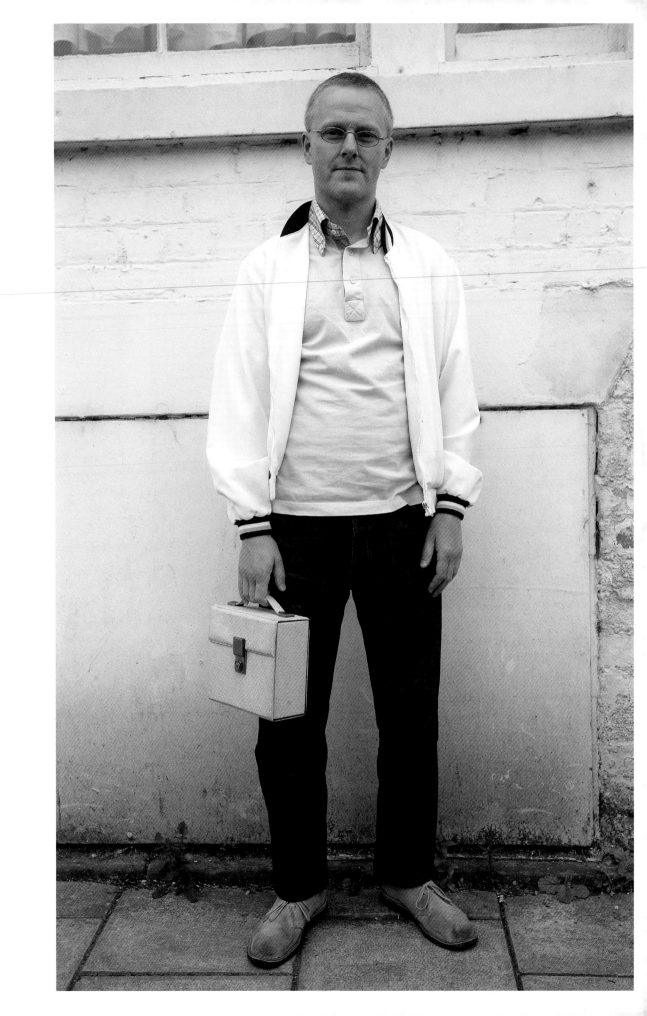

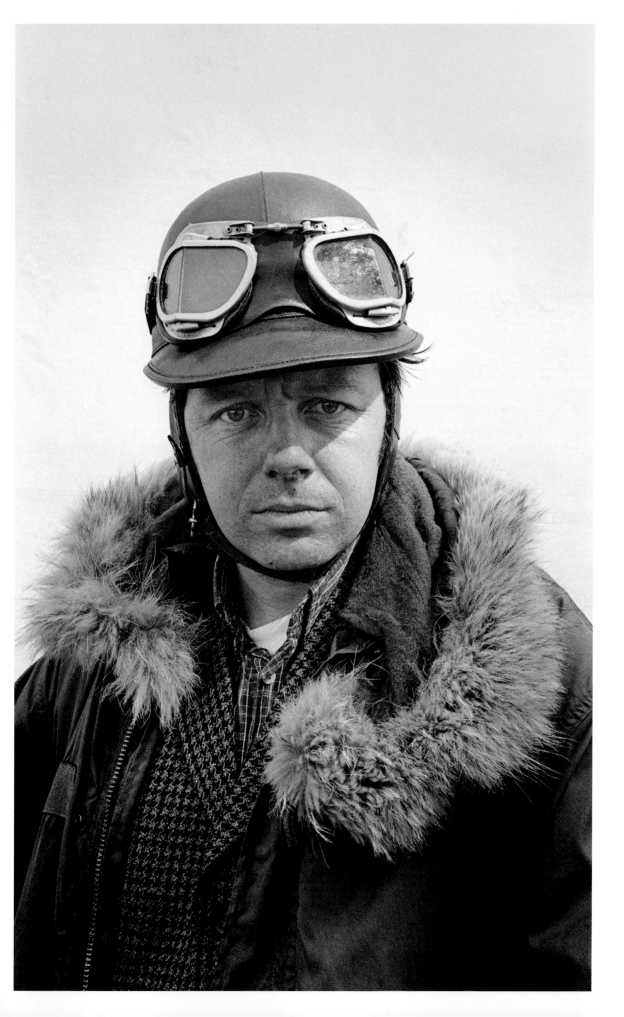

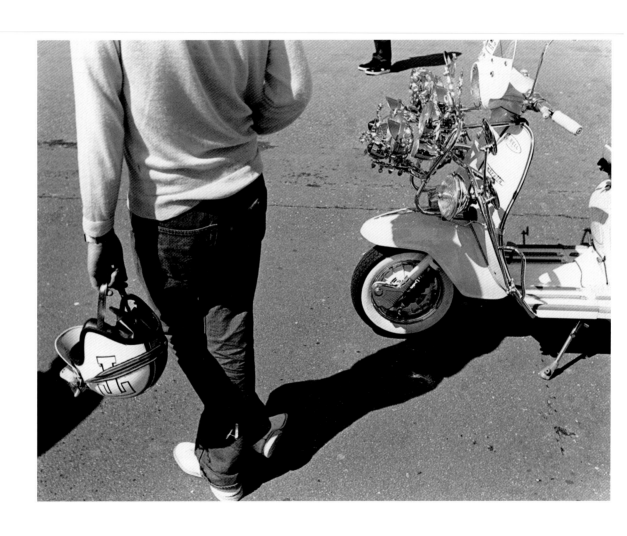

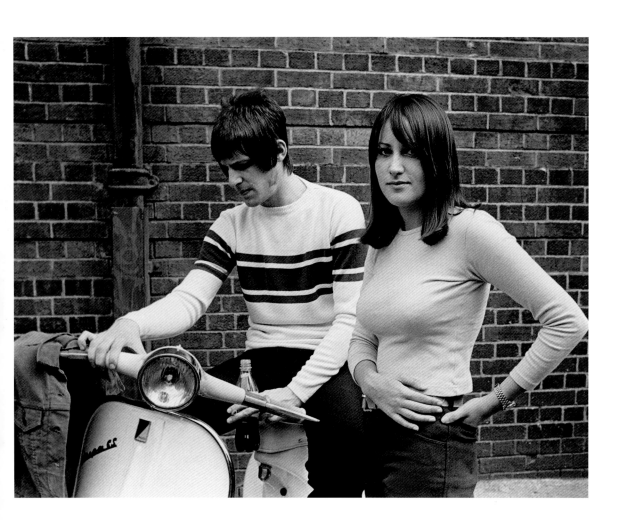

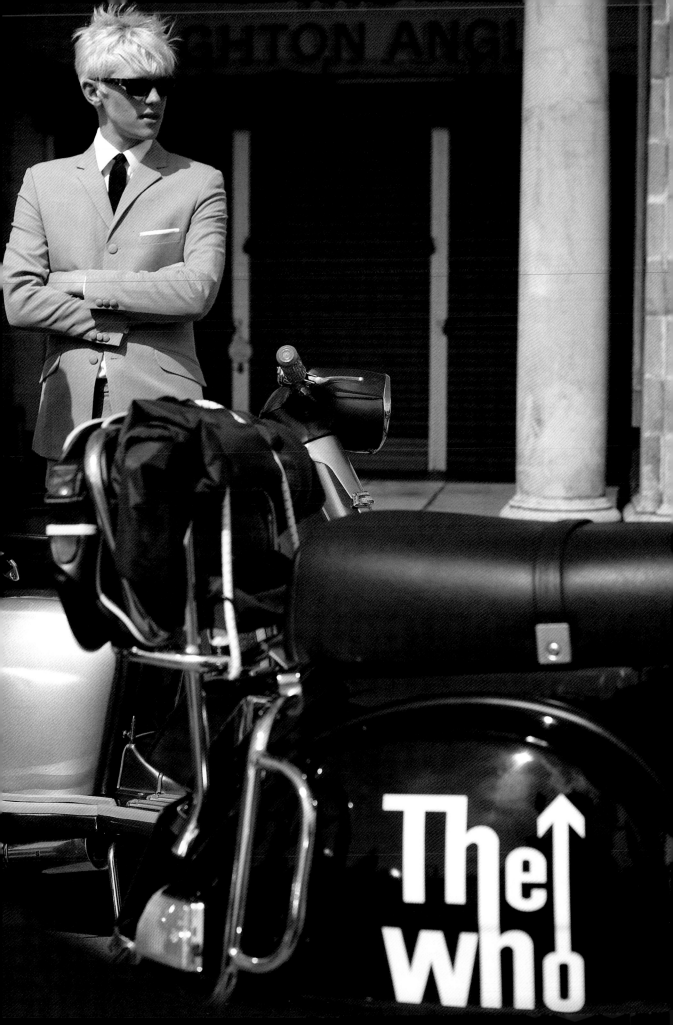

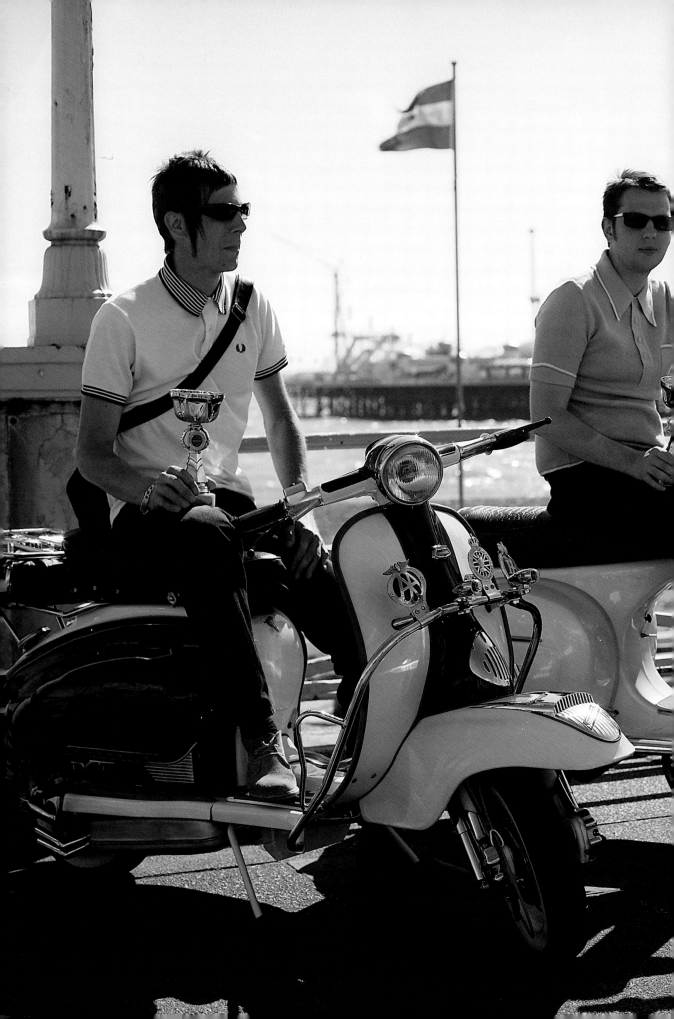

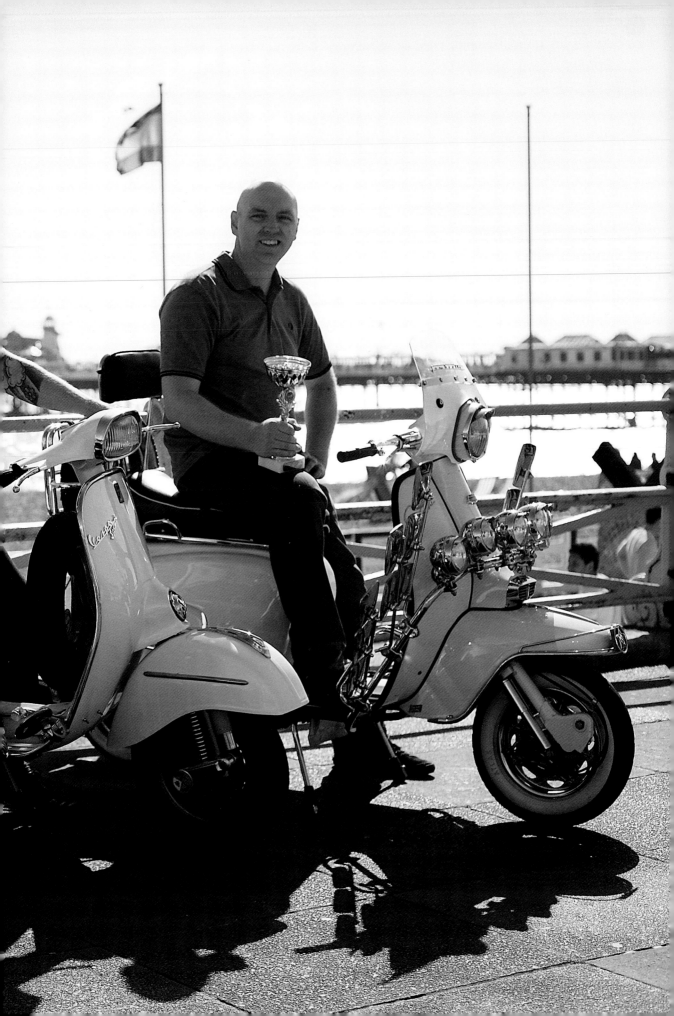

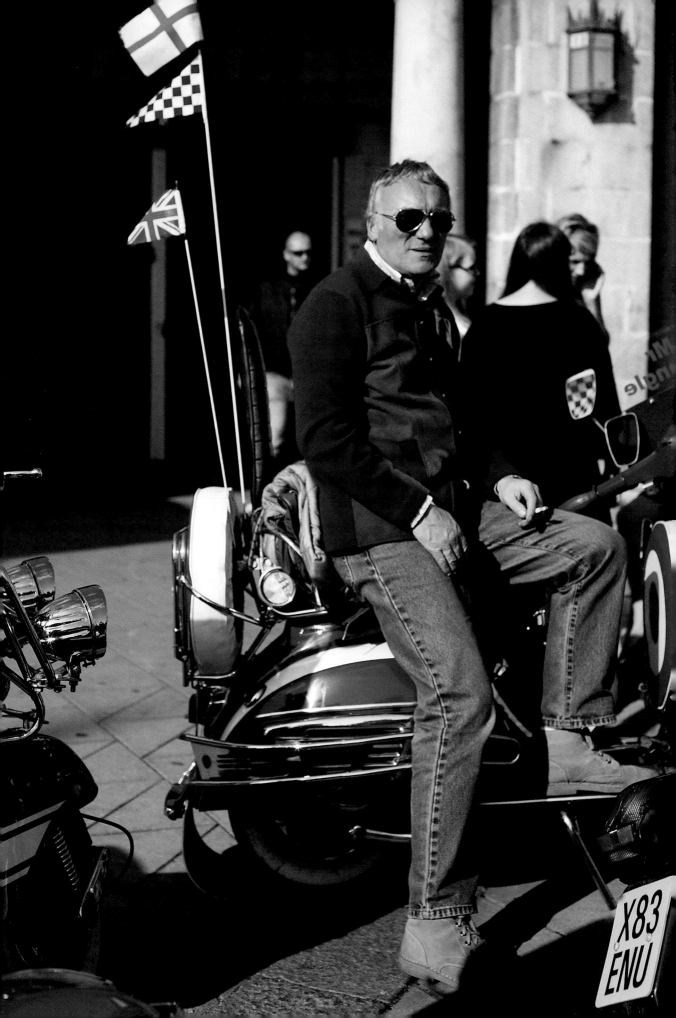

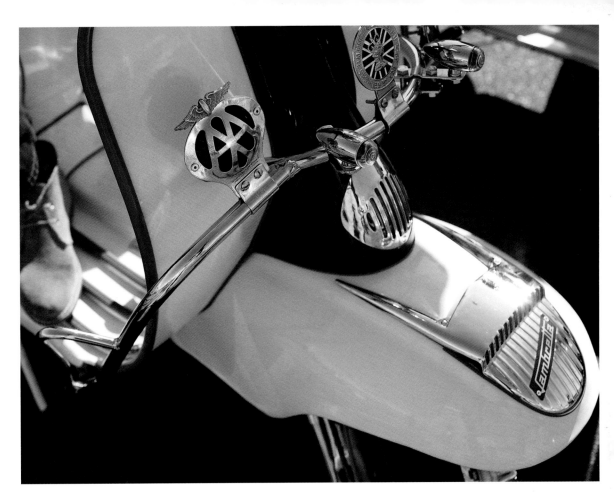

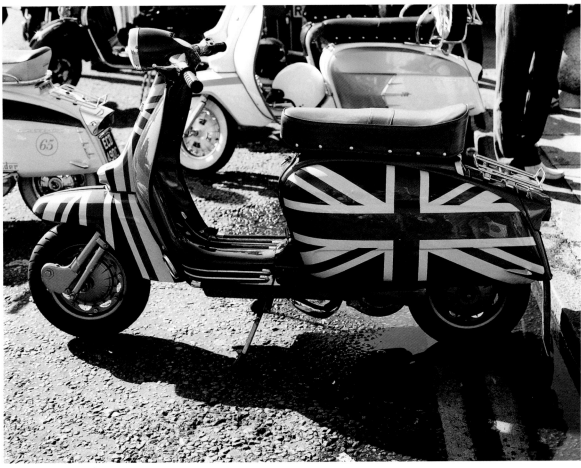

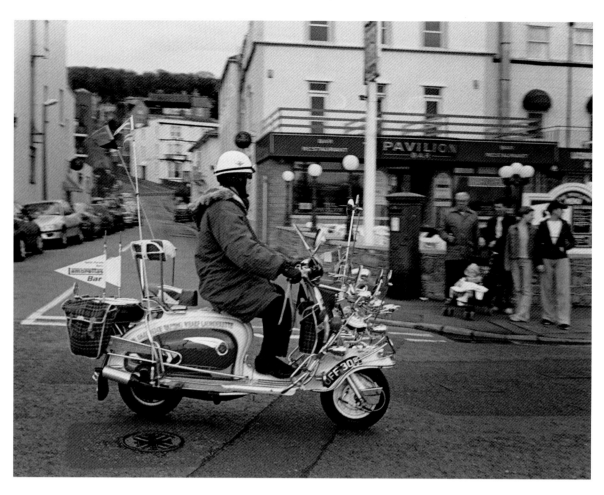

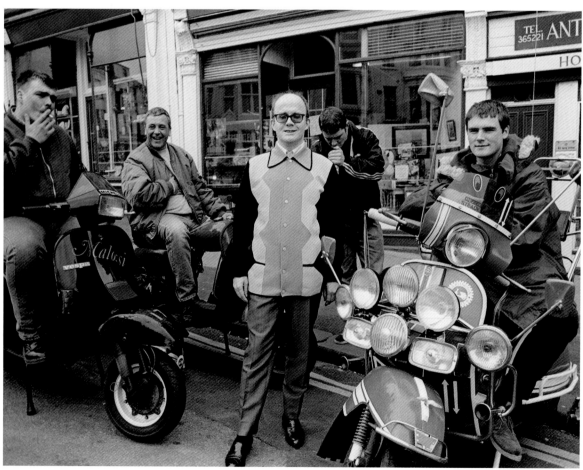

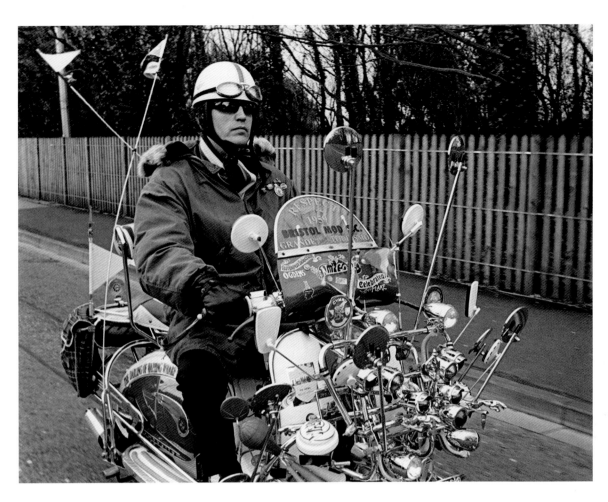

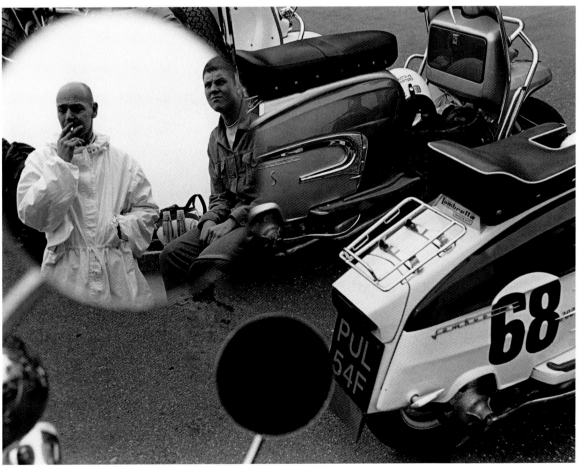

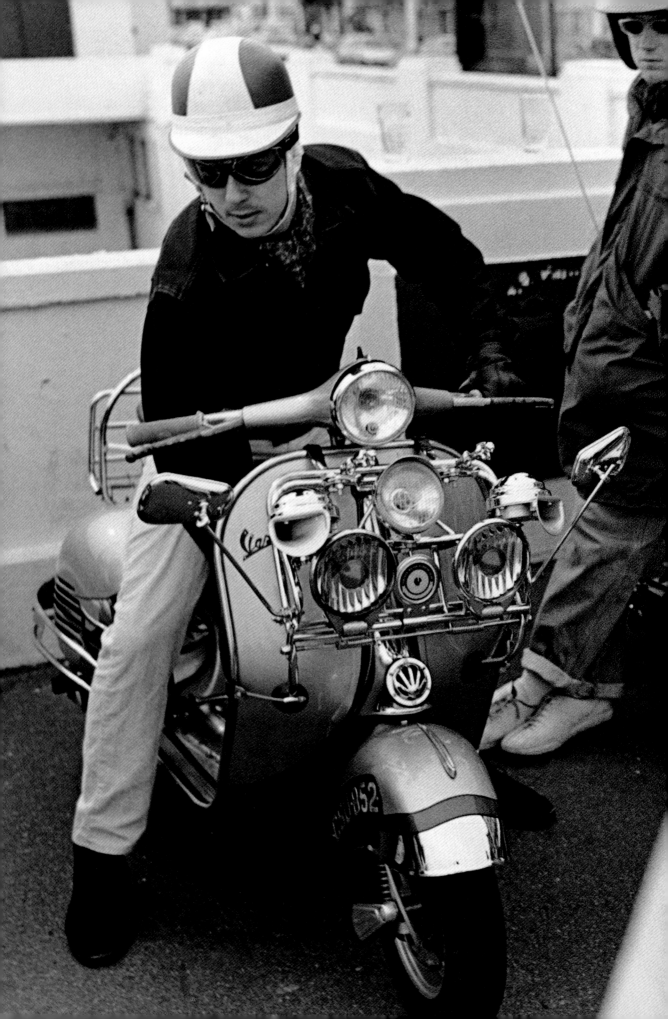

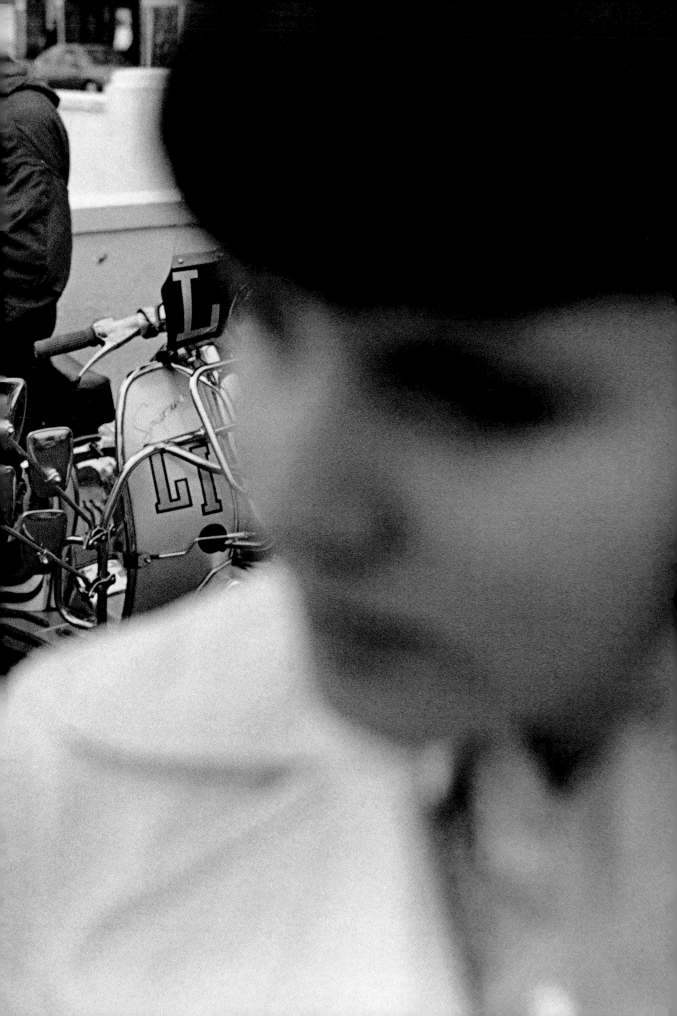

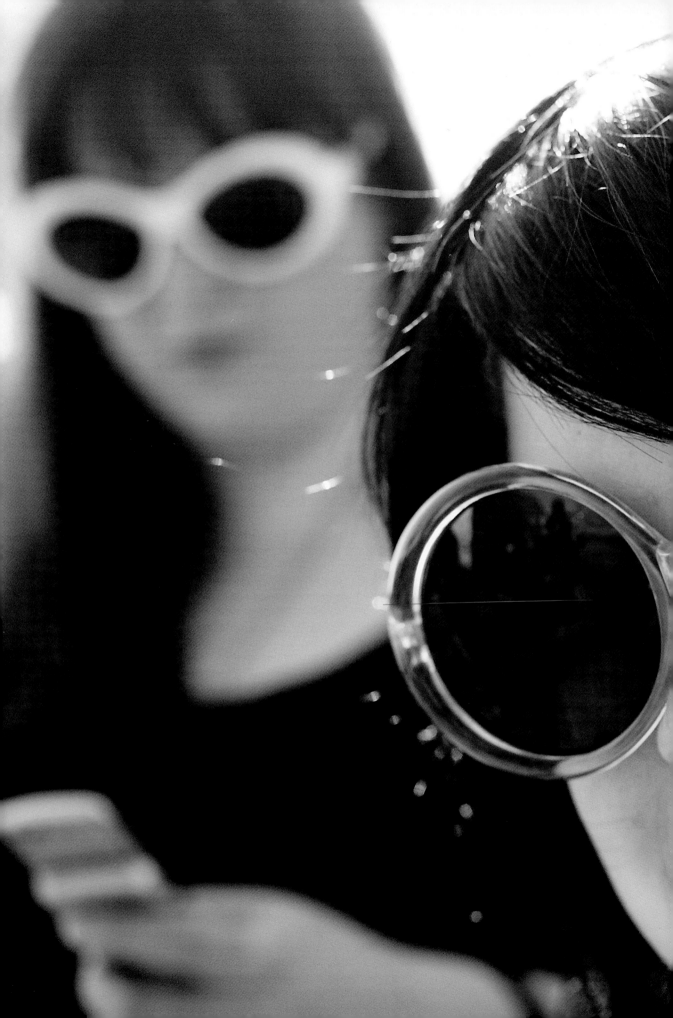

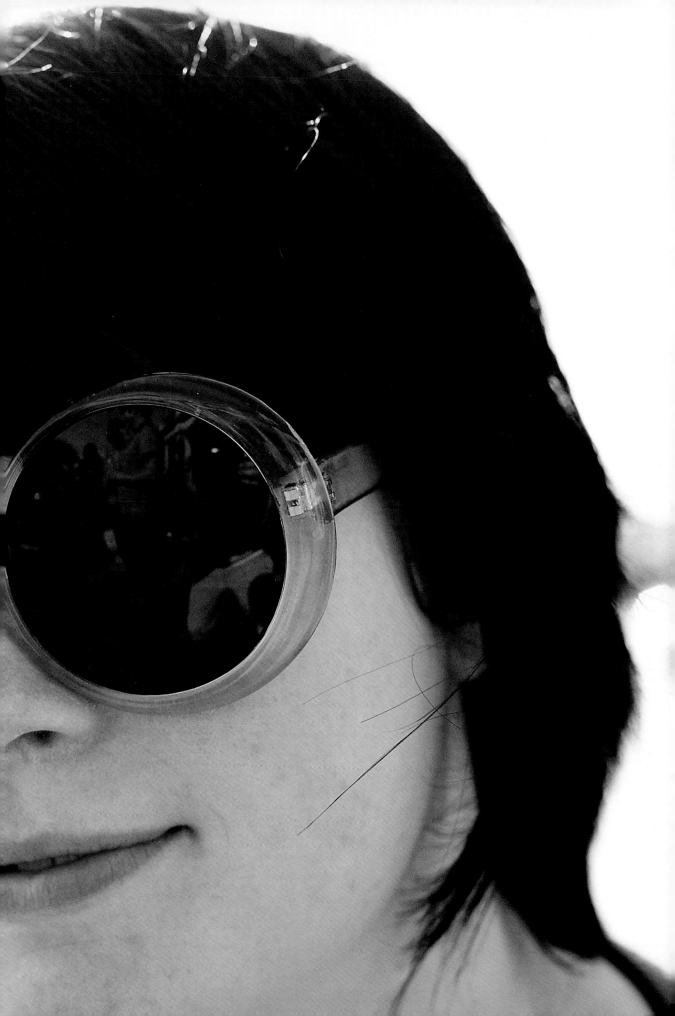

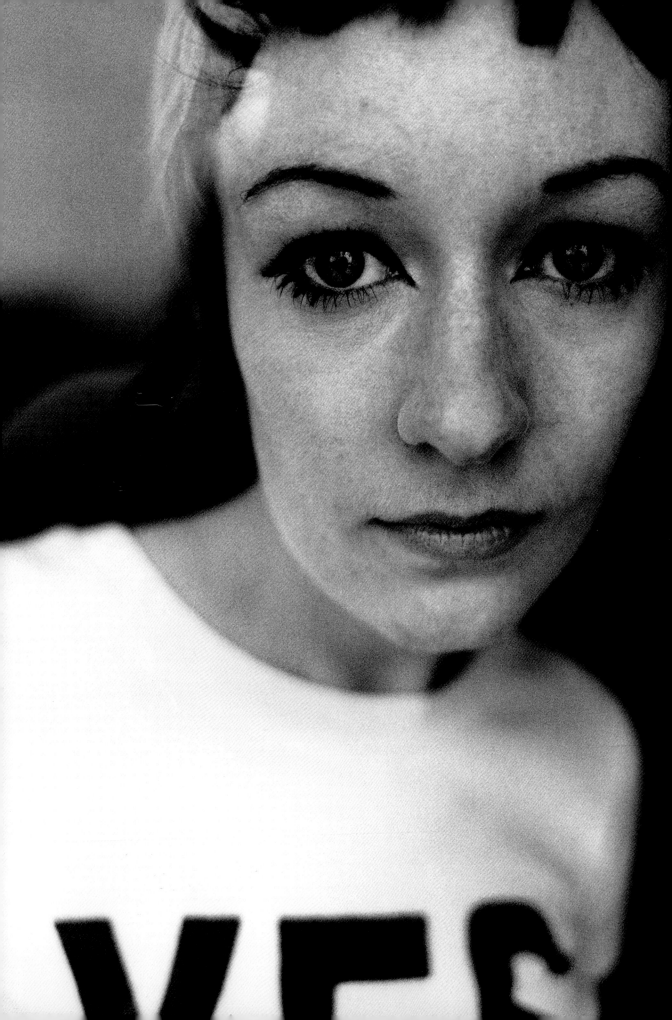

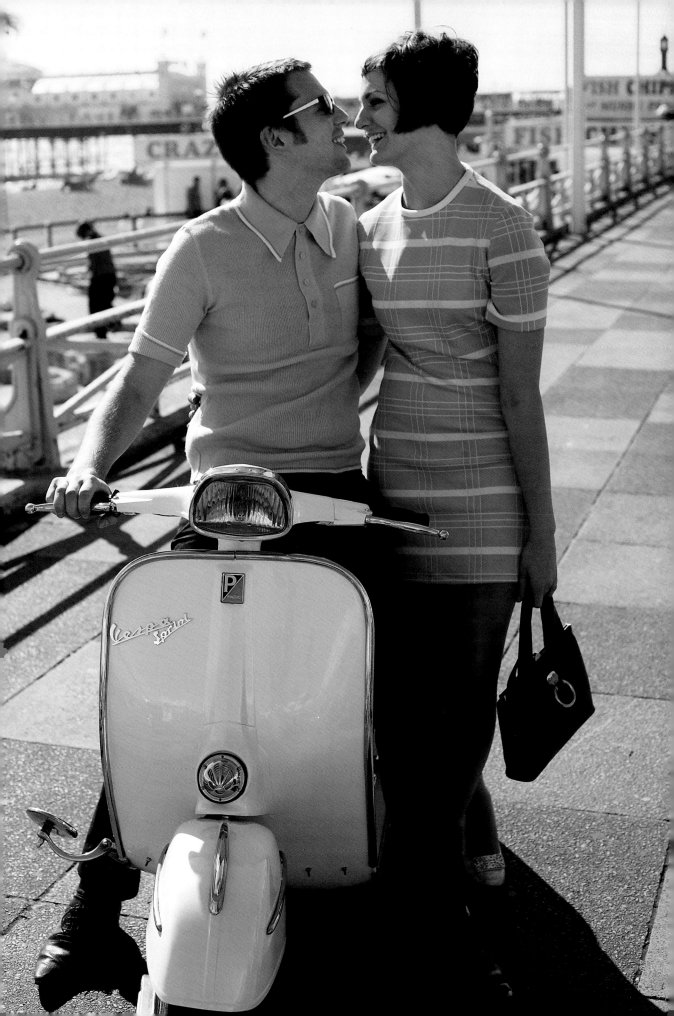

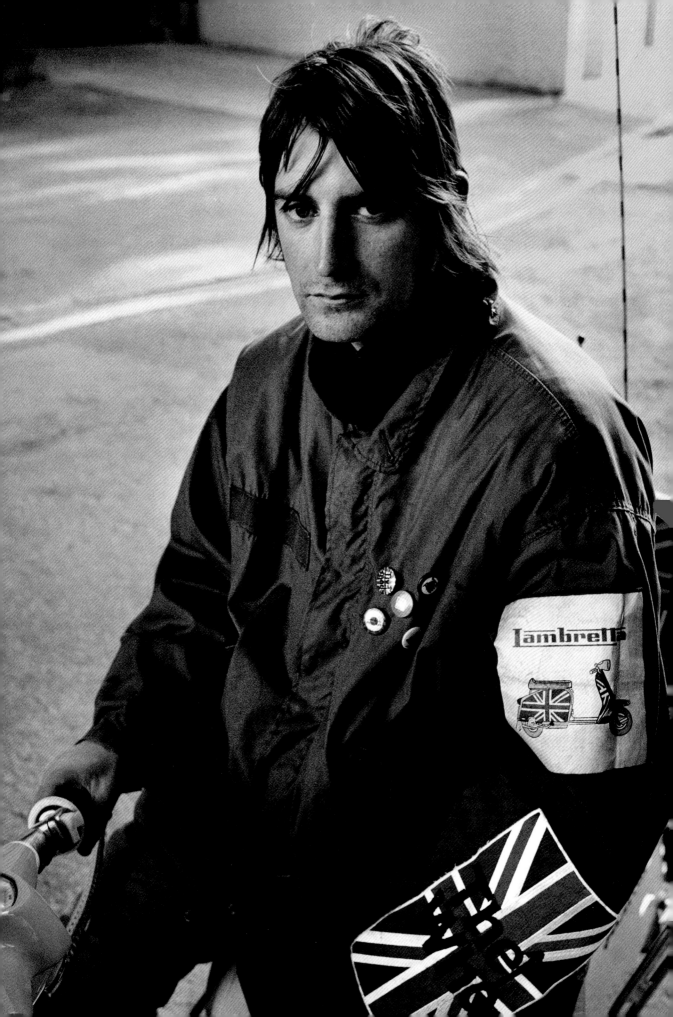

INDIVIDUALLY, WE ARE SEEKING OUT OUR OWN DISTINCTIVE IDENTITY REINFORCED BY NOSTALGIA FOR WHAT WENT BEFORE.
THERE IS A JUXTAPOSITION OF THE QUEST FOR UNIQUE IDENTITY AND A CRAVING TO BELONG TO THIS PARTICULAR SUBCULTURE.

AOIFE

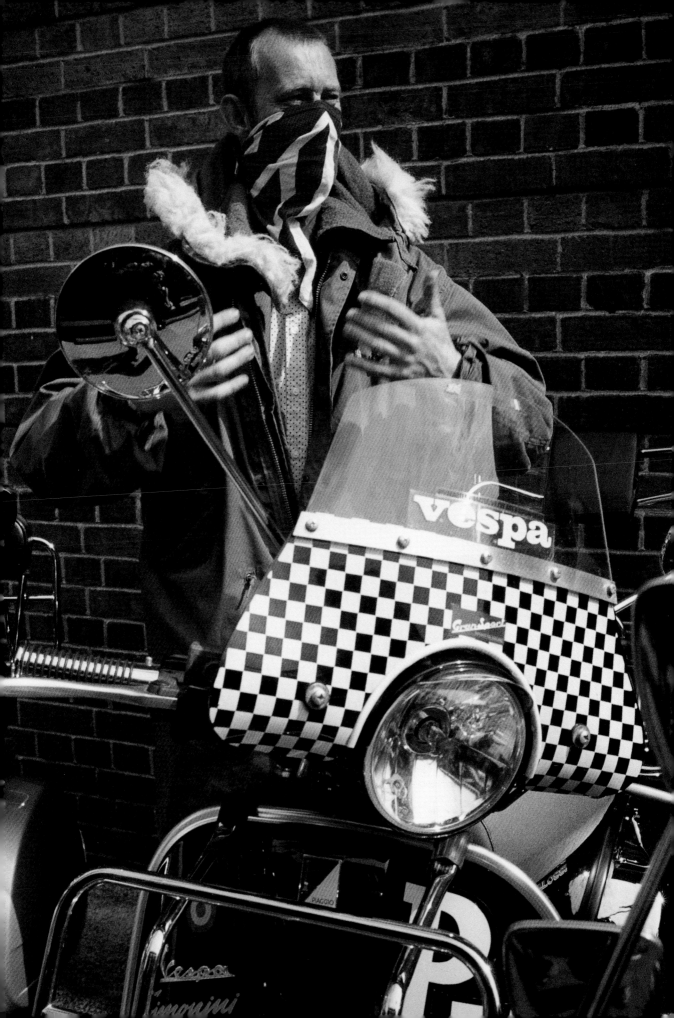

I LIKE A NEAT
BUT ECLECTIC LOOK.
THE PAST IS OVER
BUT THE SPIRIT OF MOD
NEVER DIES.
CLAIRE

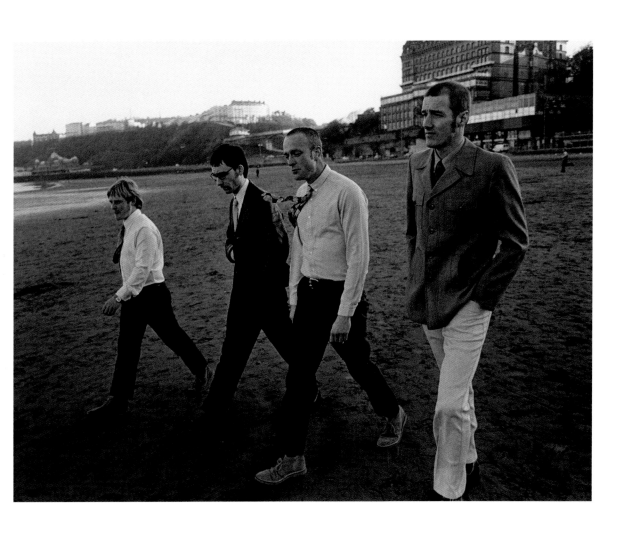

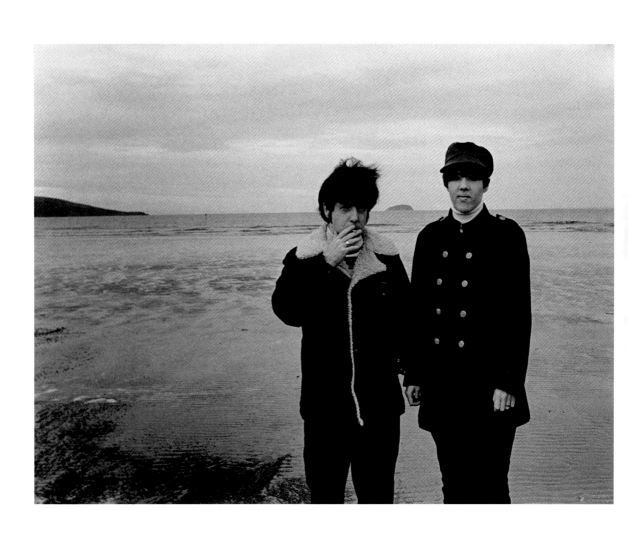

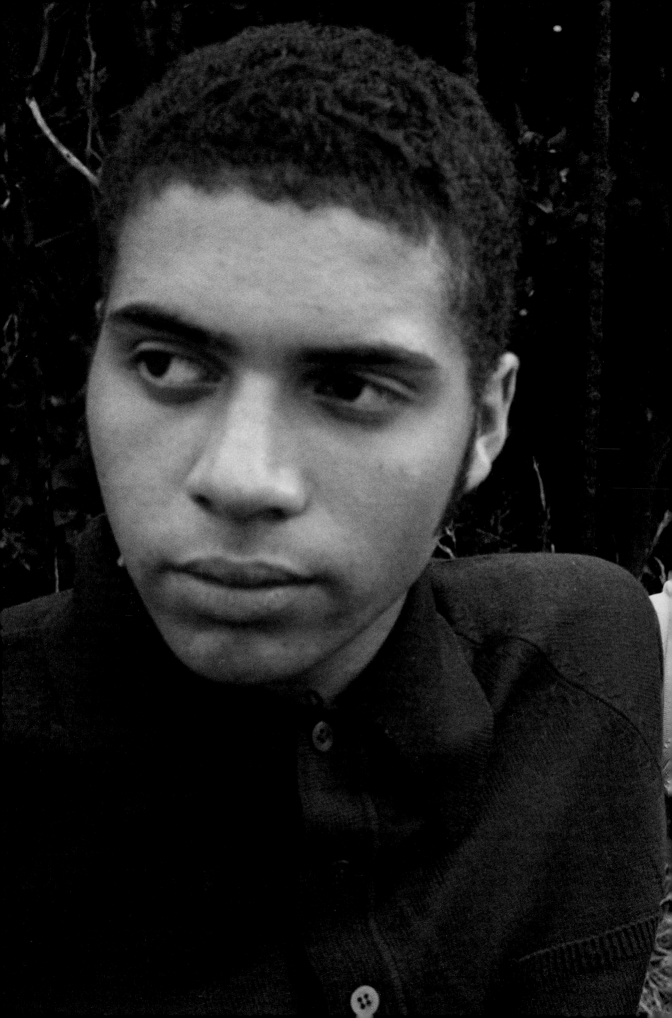

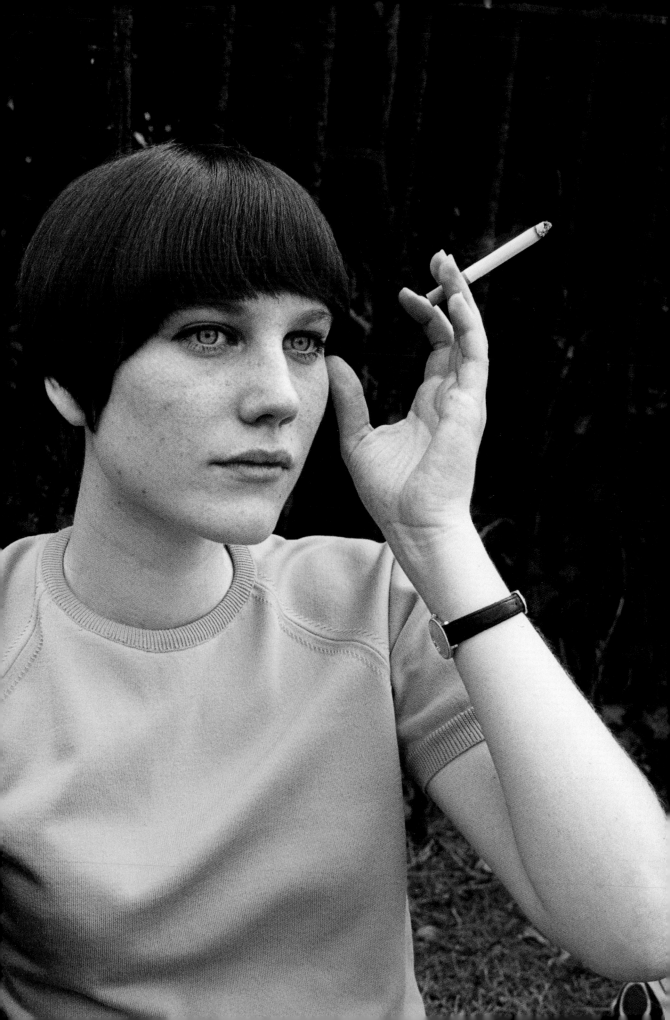

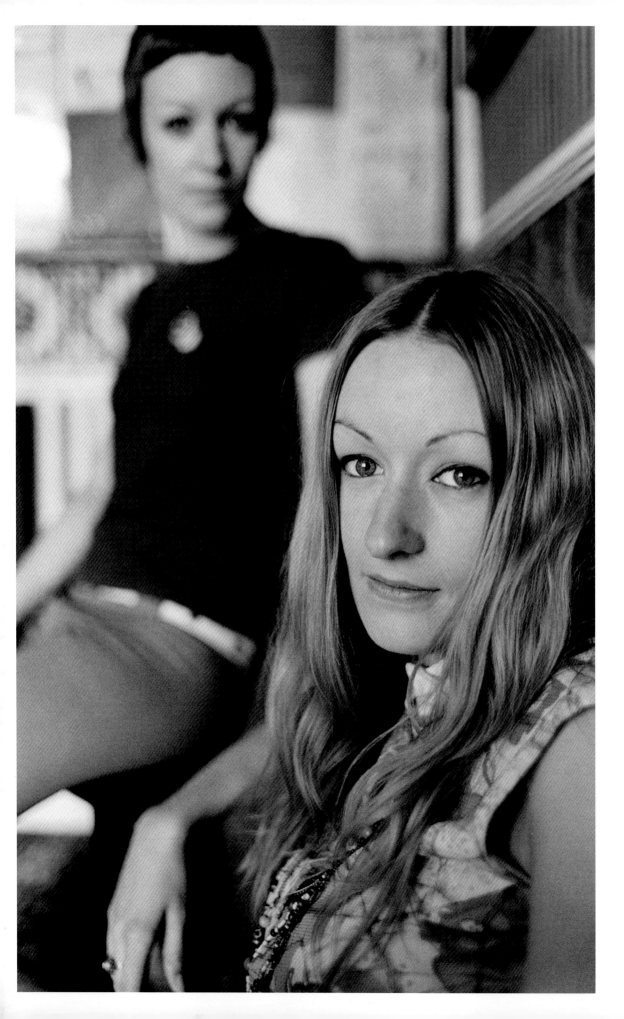

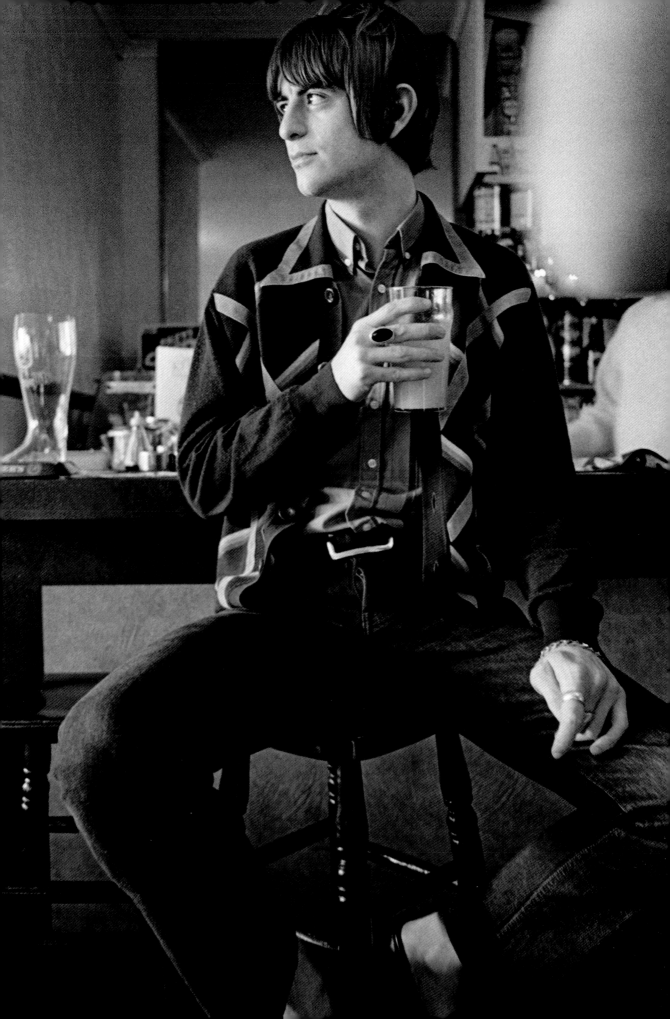

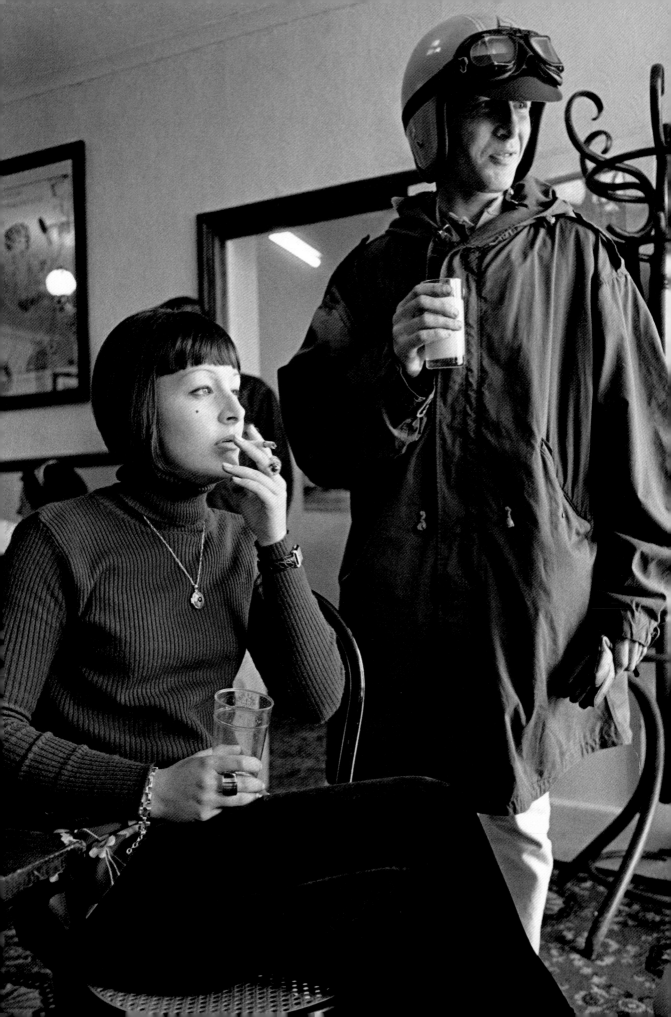

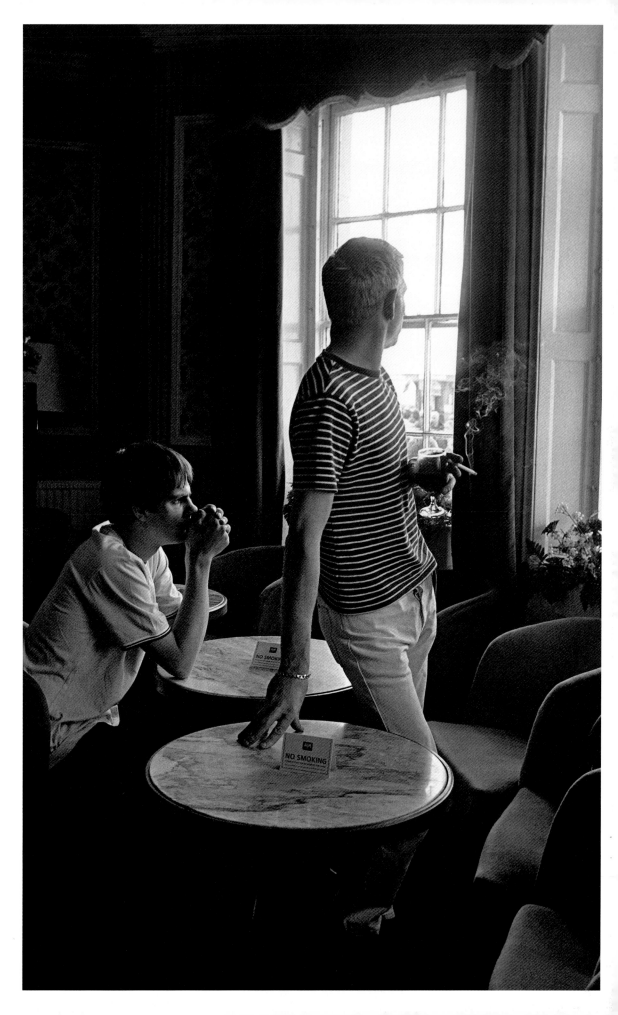

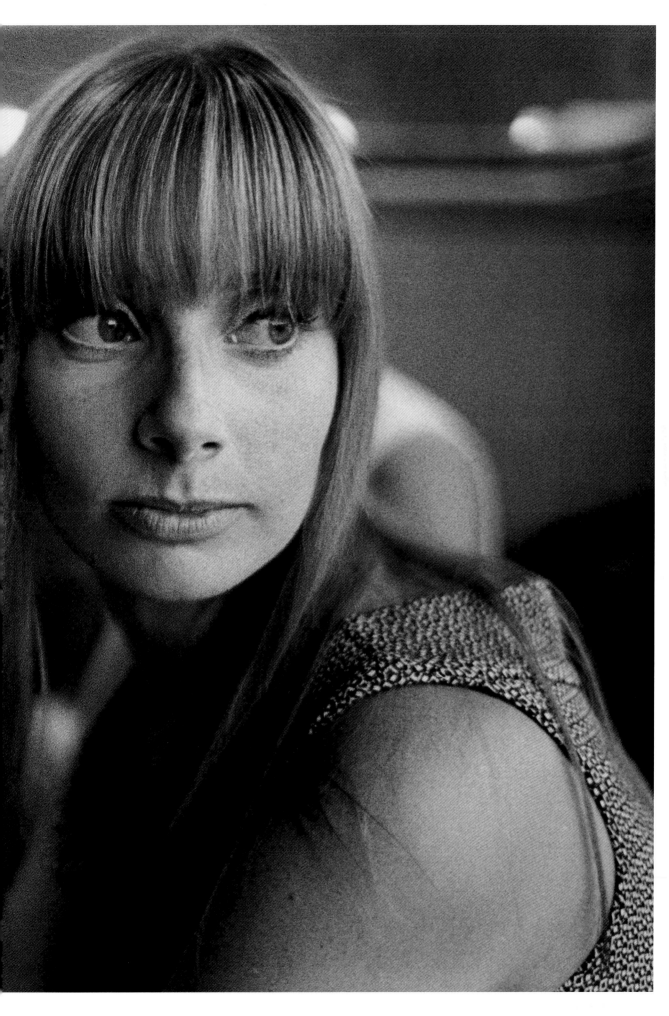

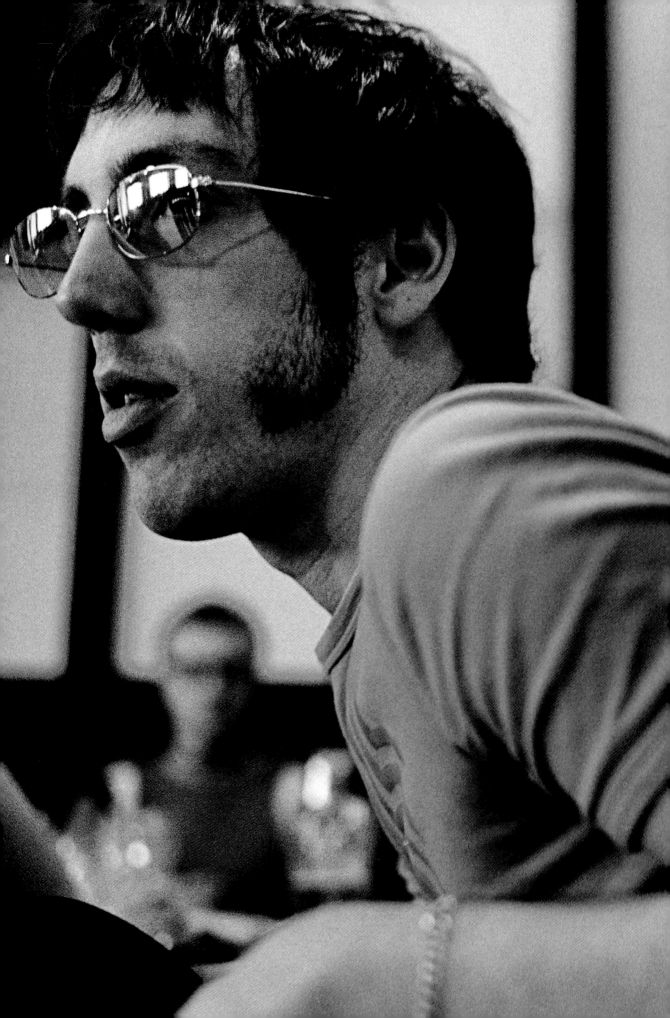

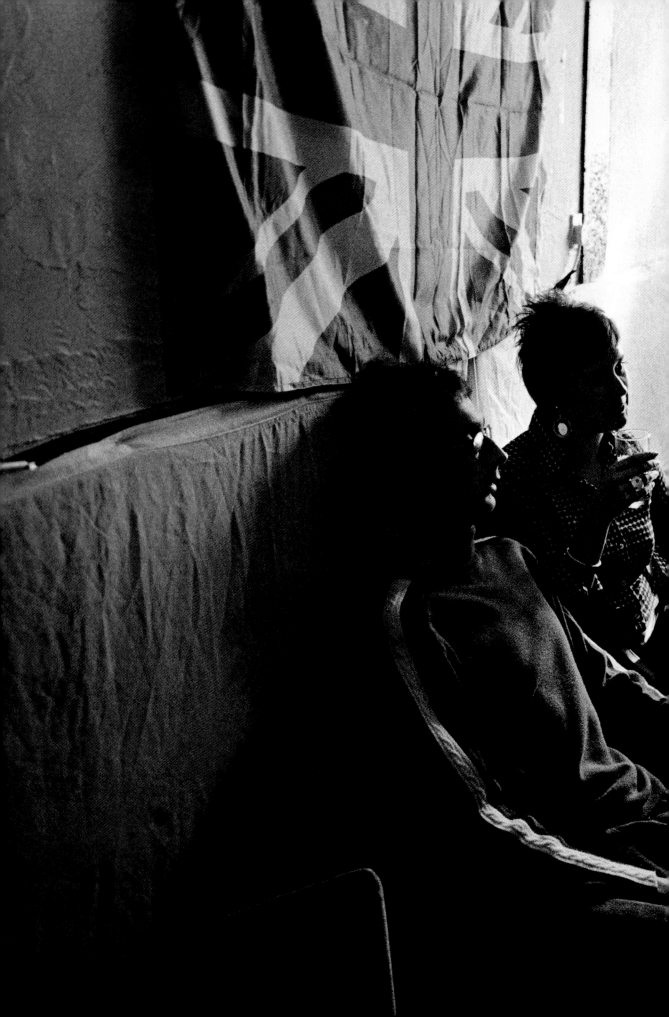

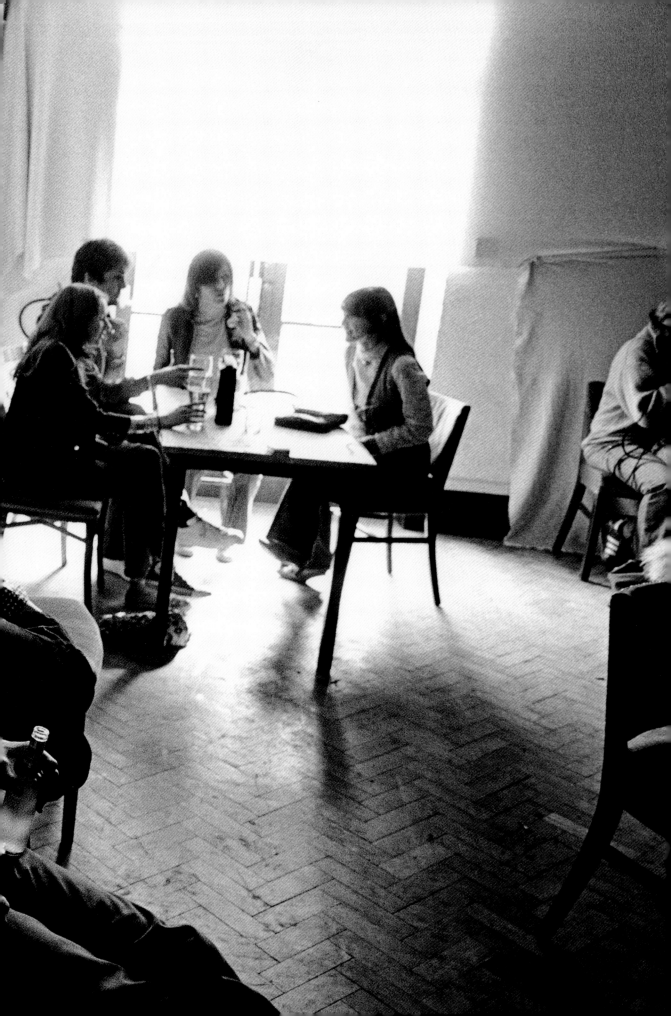

I GET OUT THERE
AND LET MY
INHIBITIONS FLOW AWAY!
ANGIE

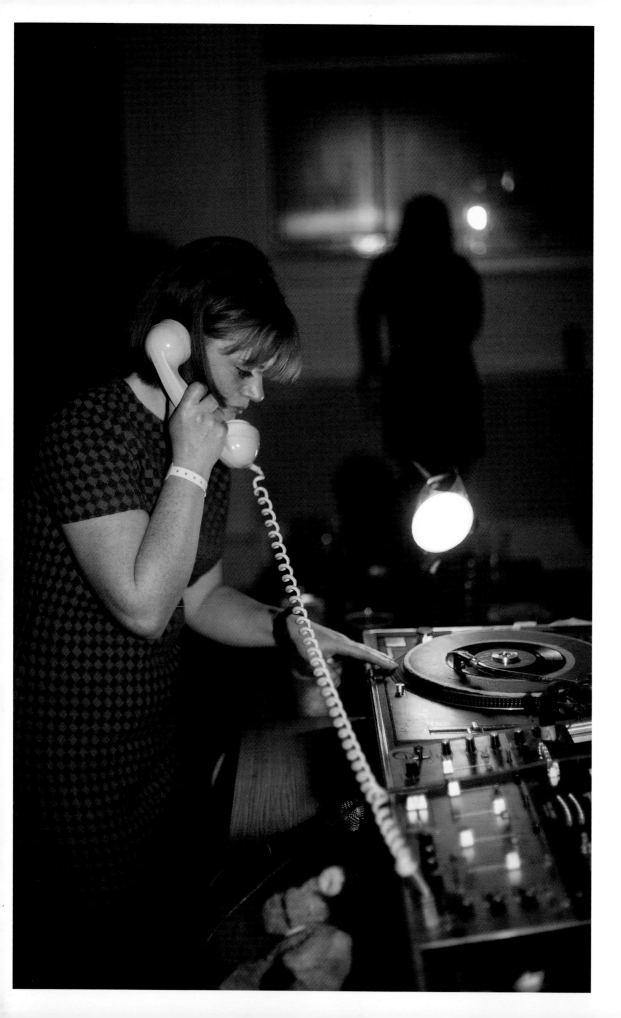

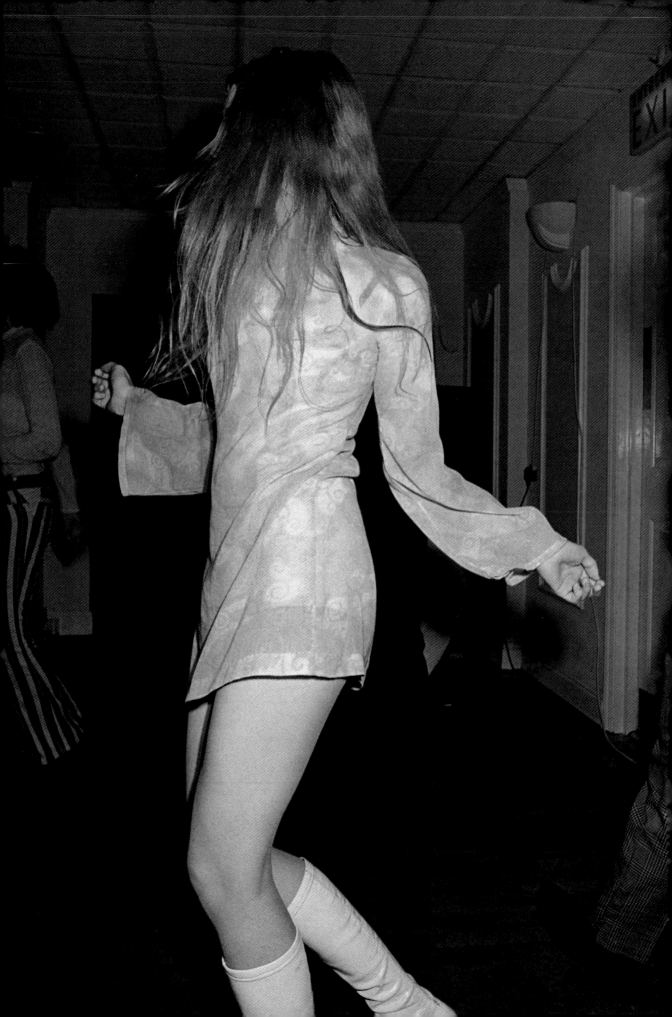

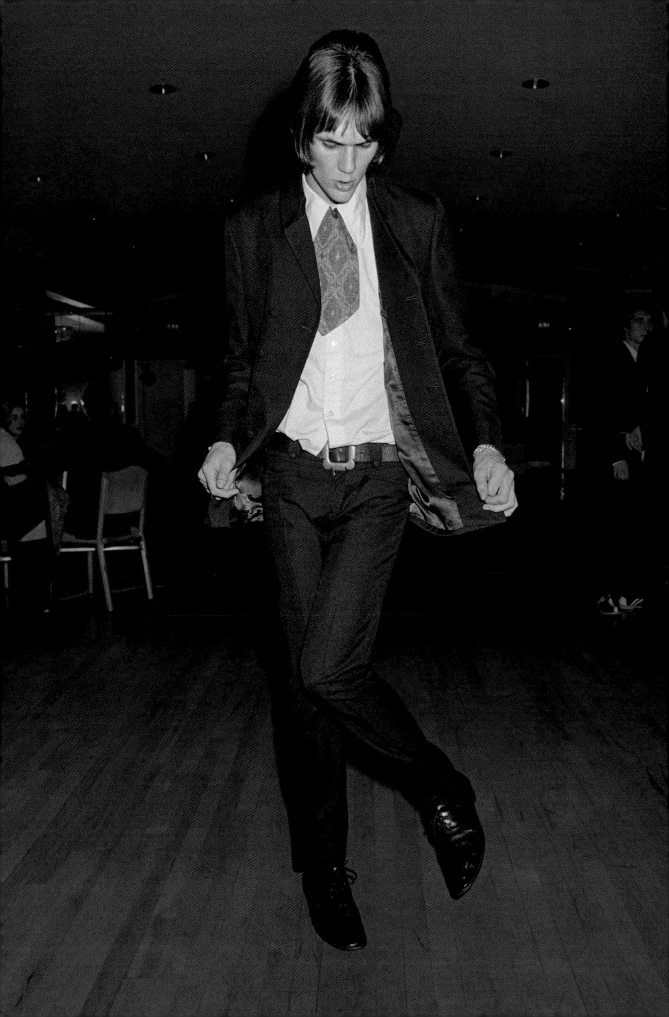

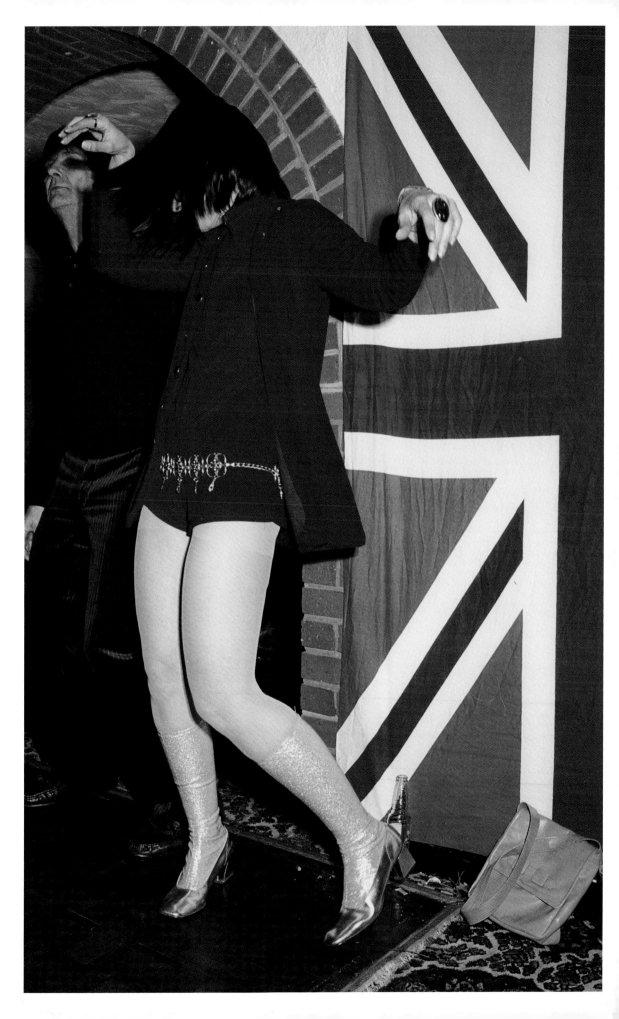

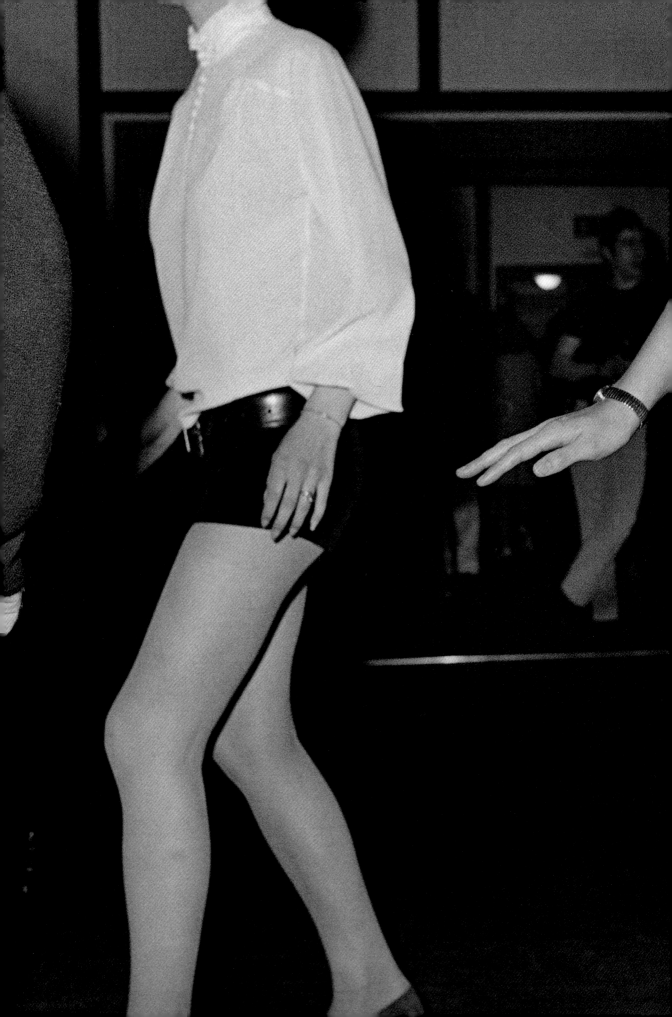

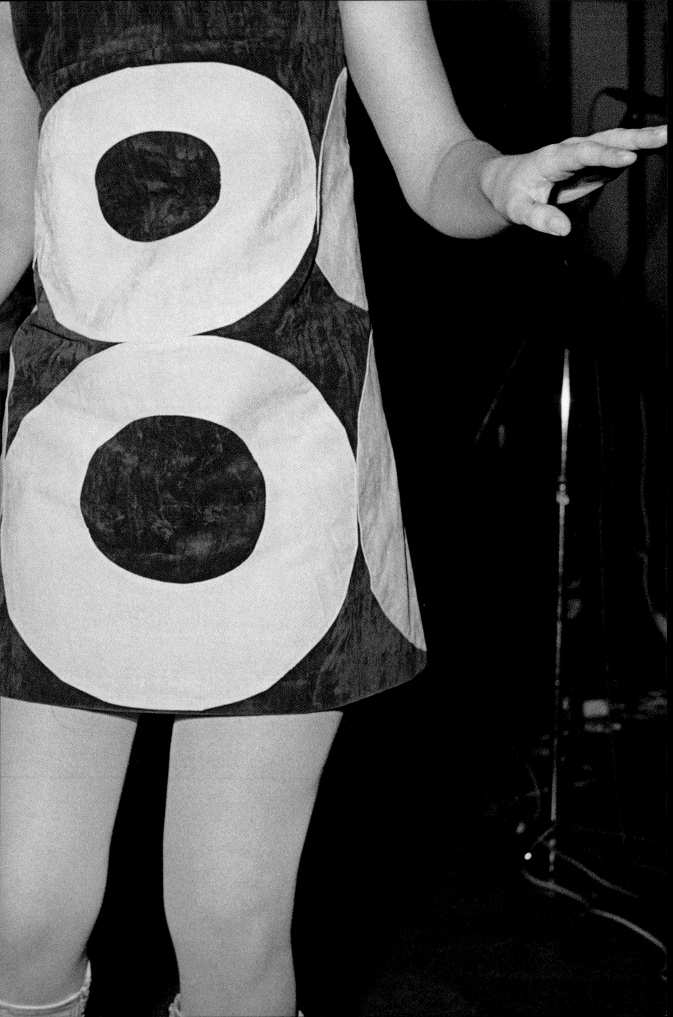

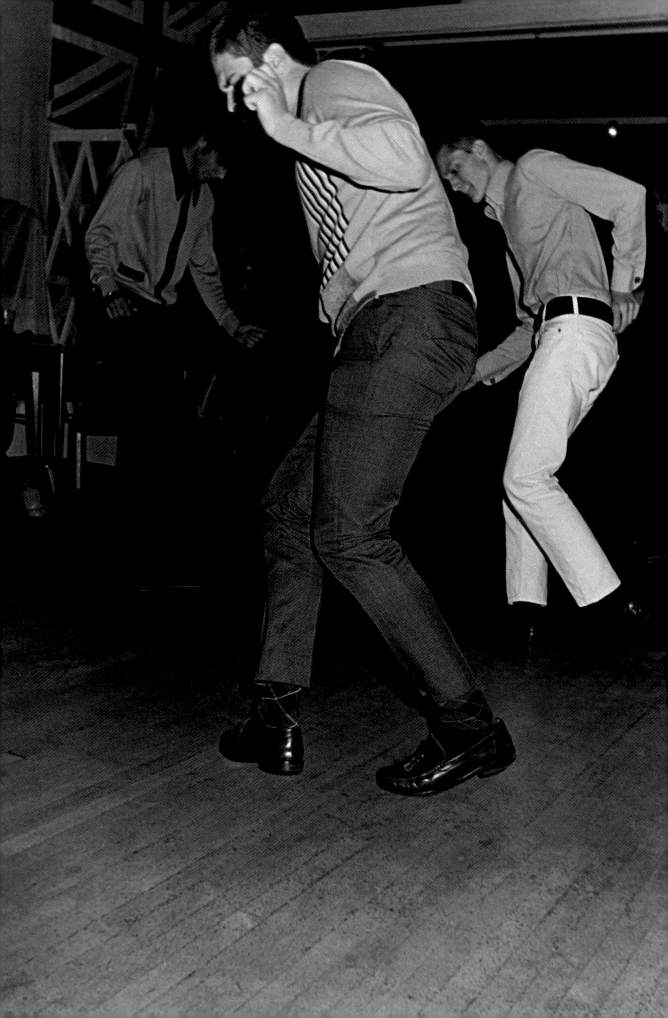

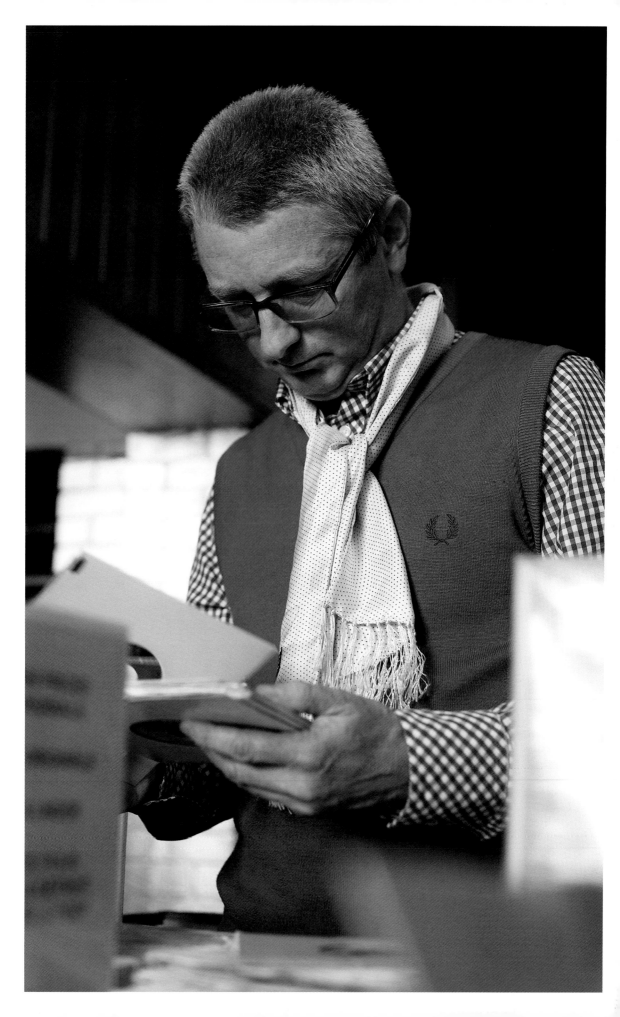

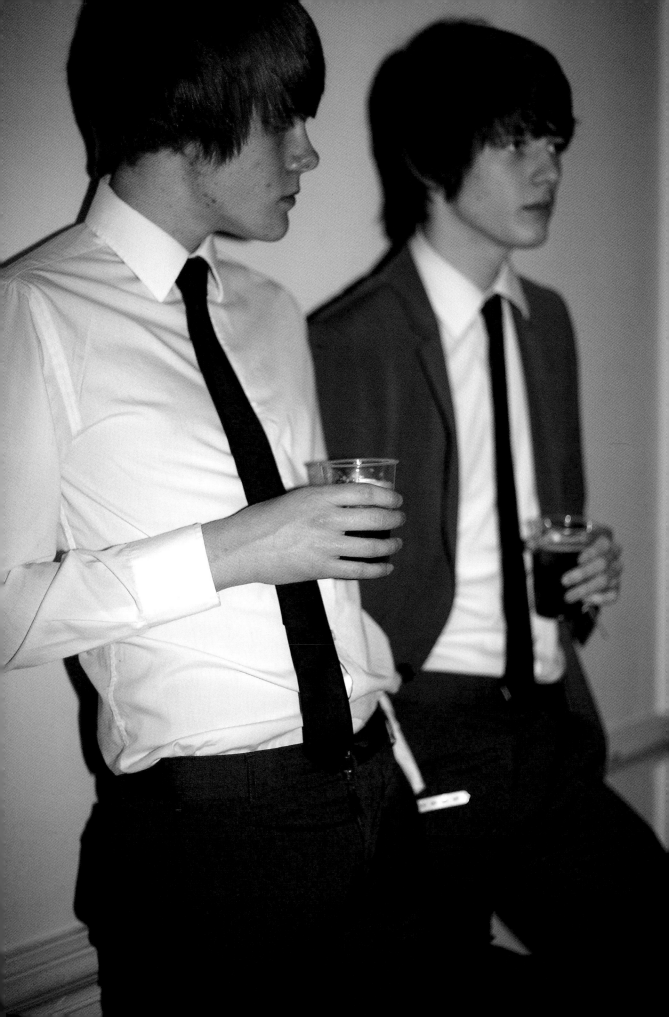

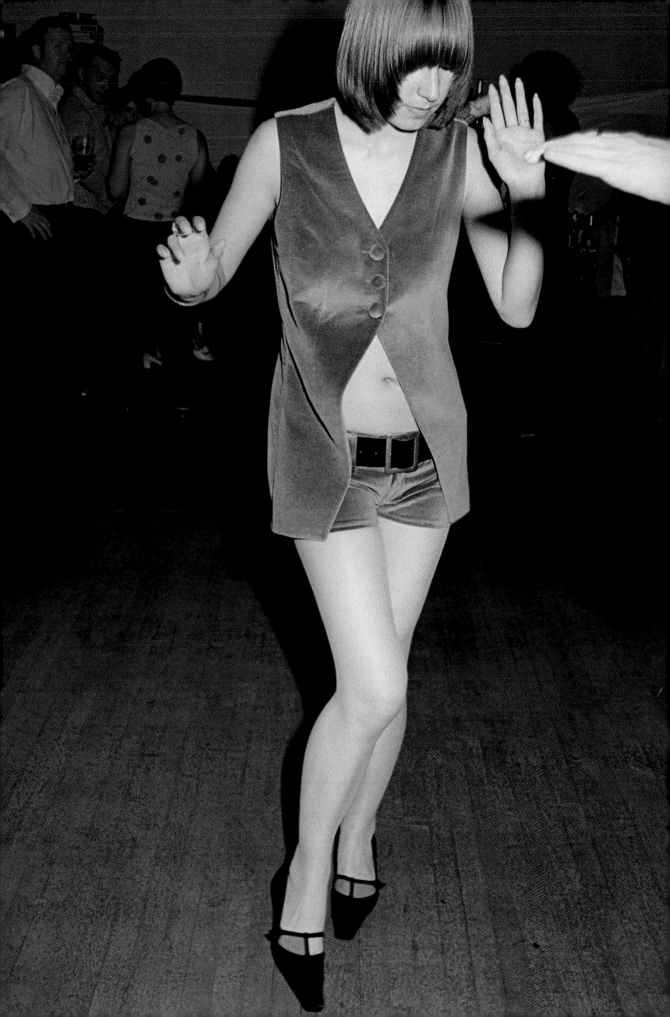

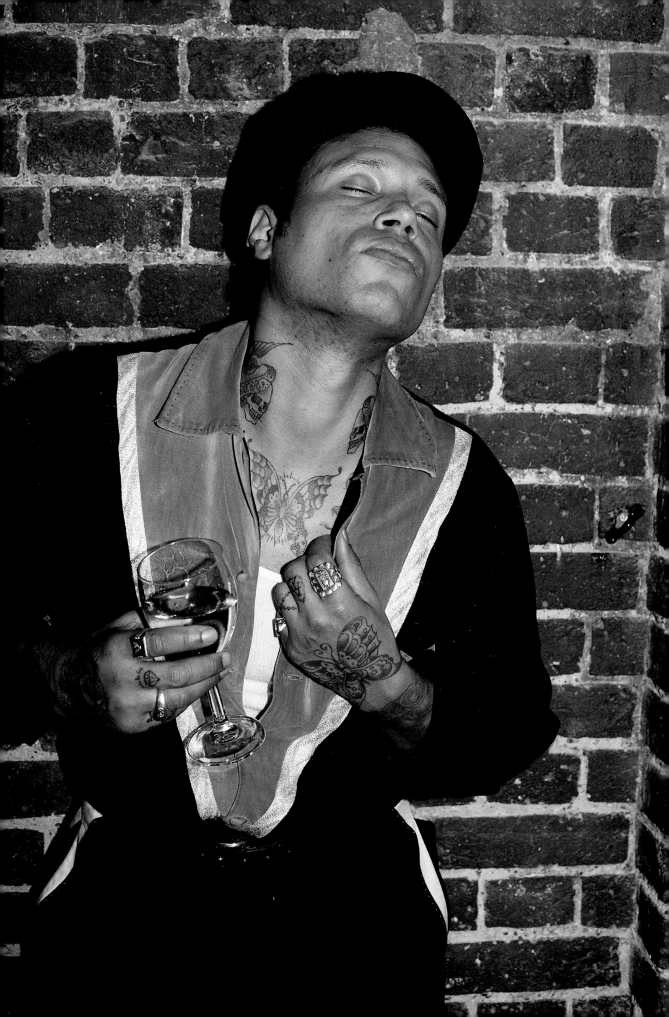

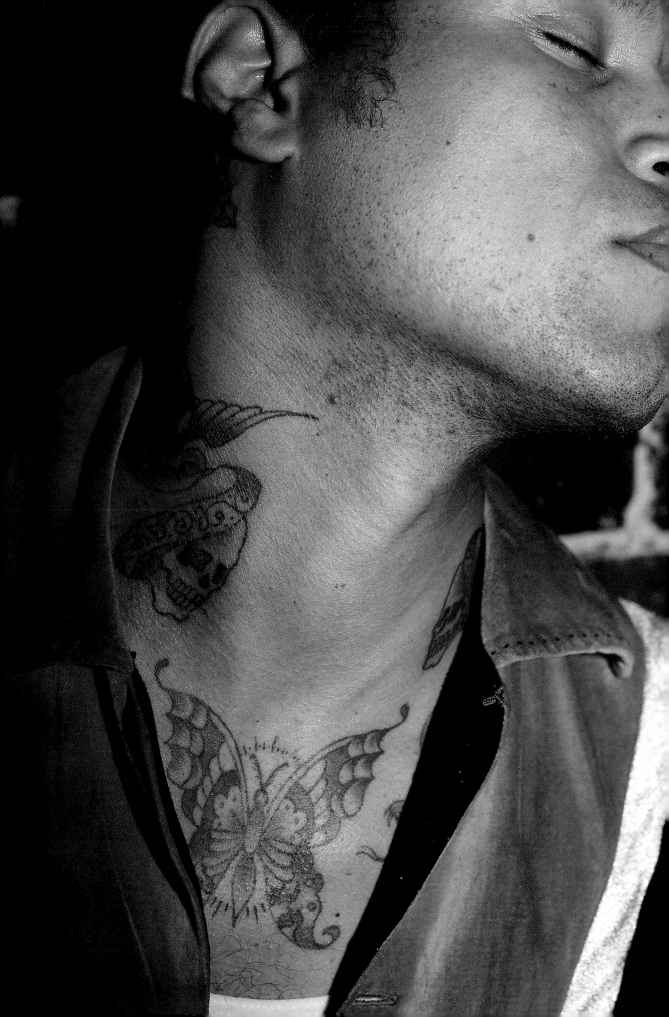

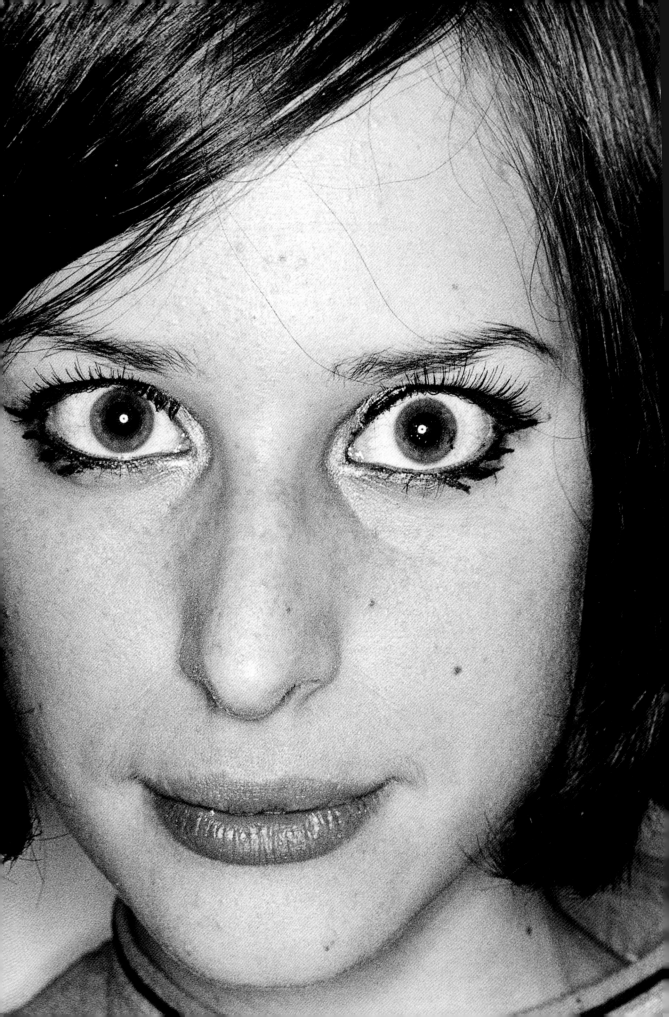

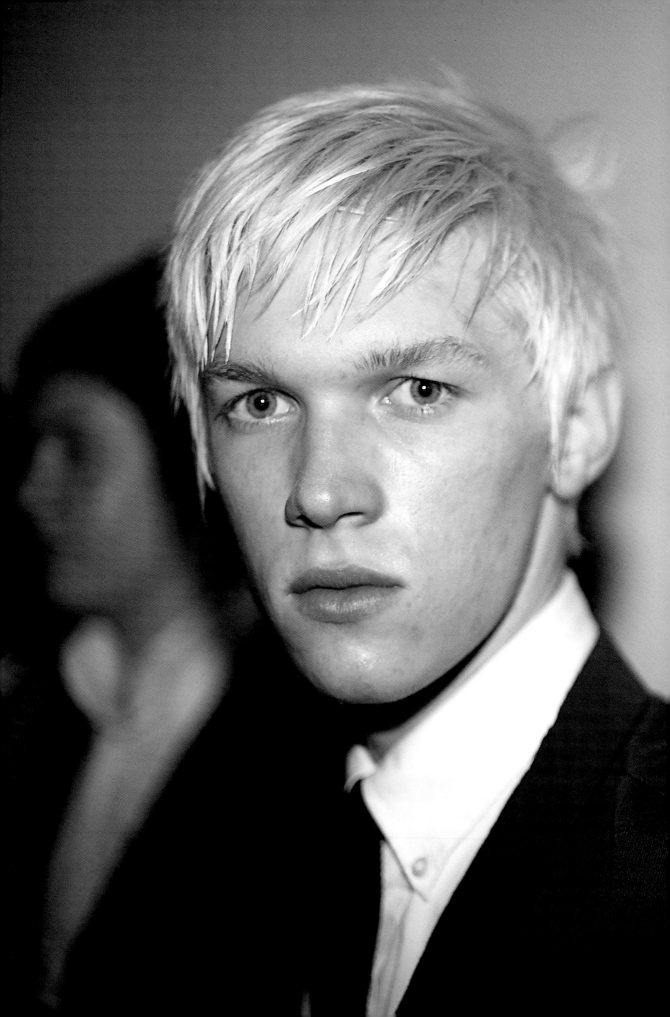

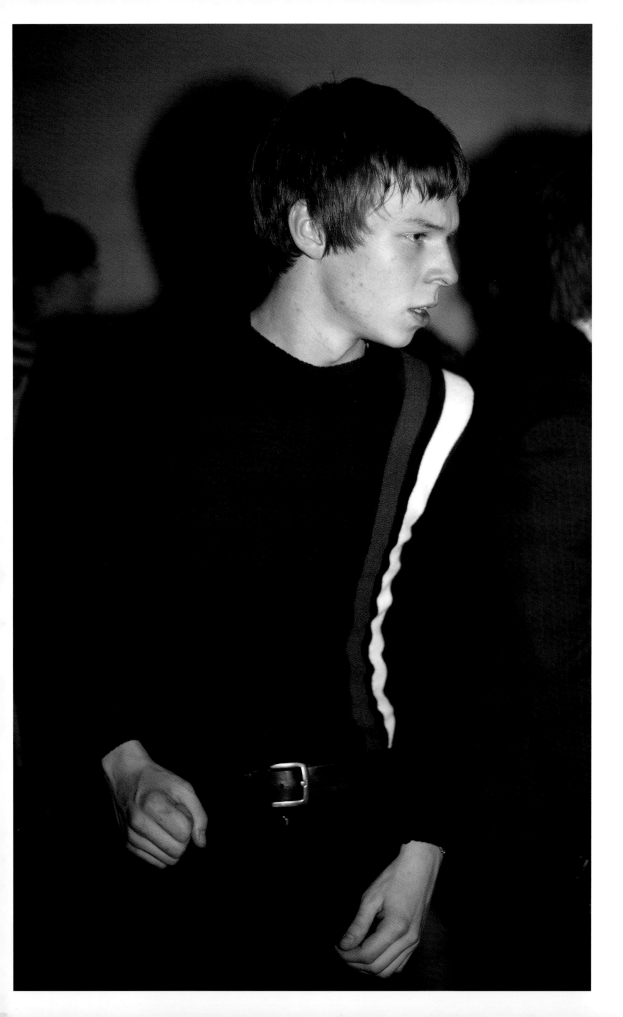

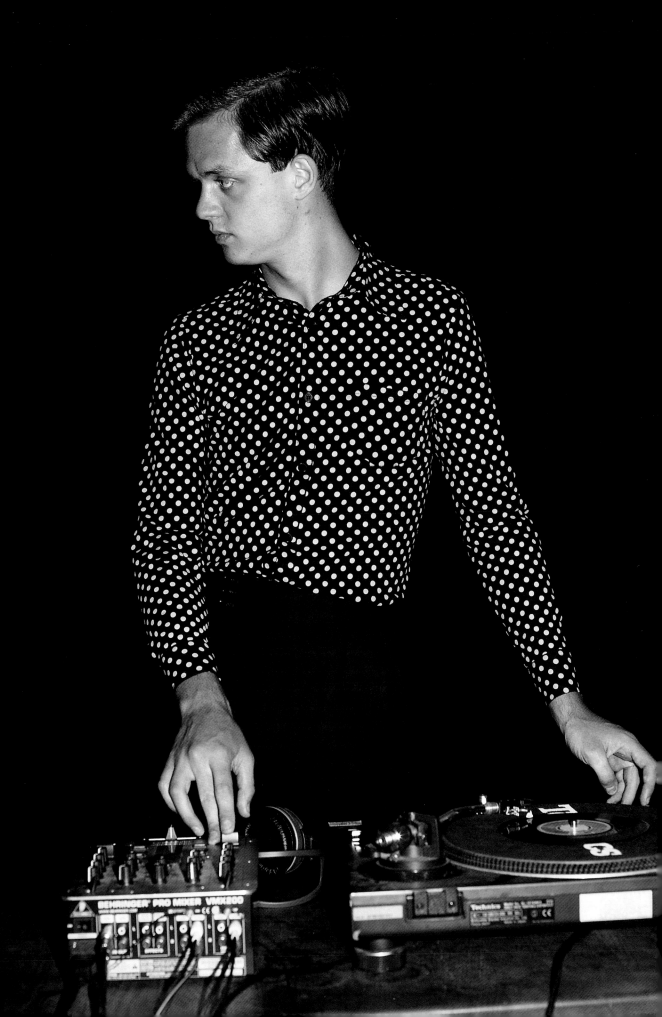

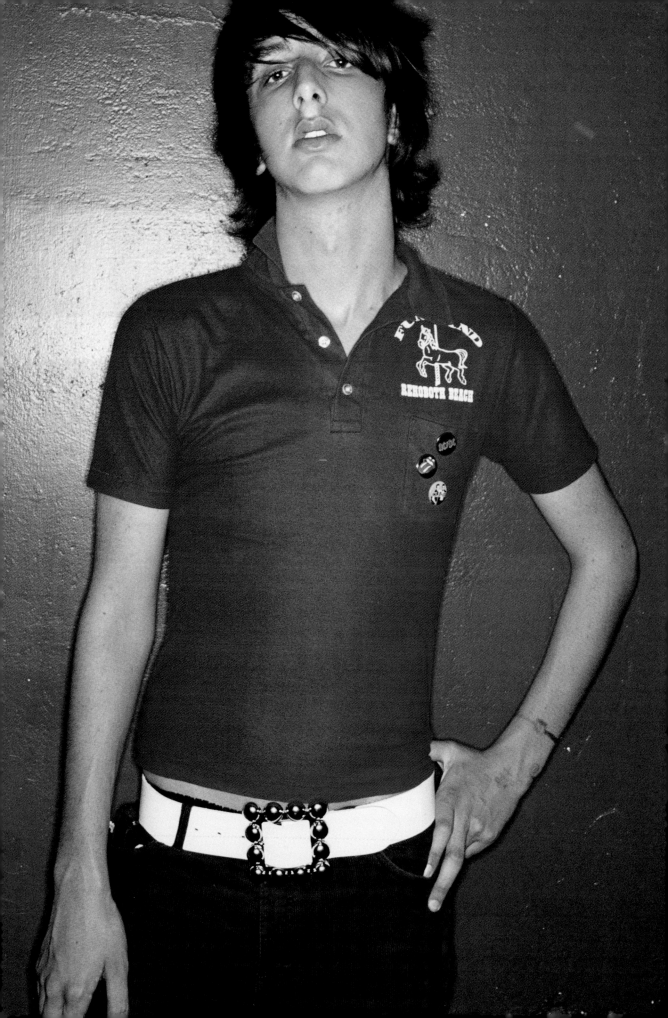

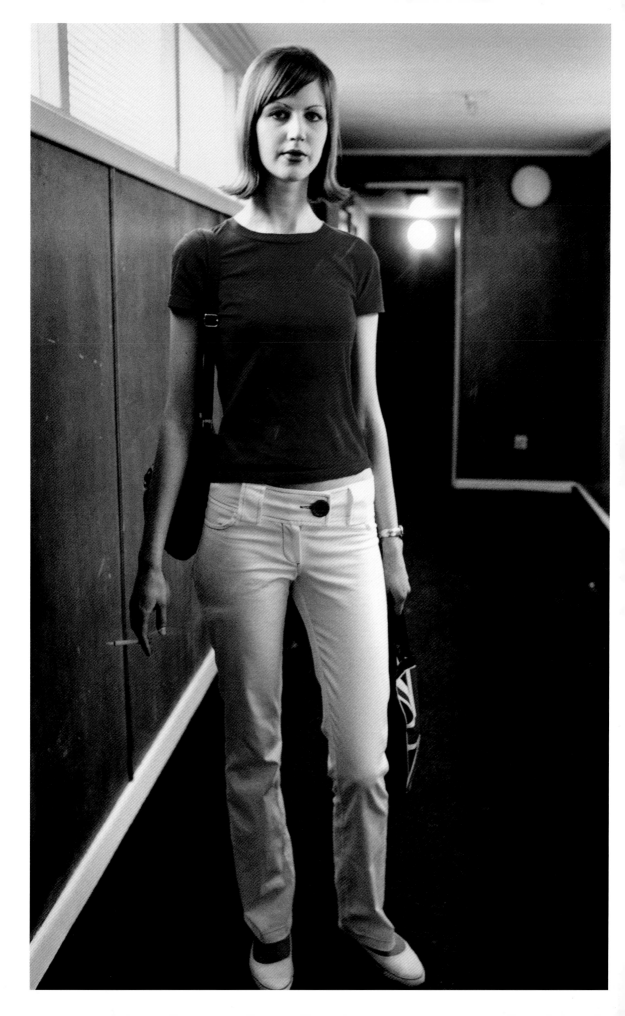

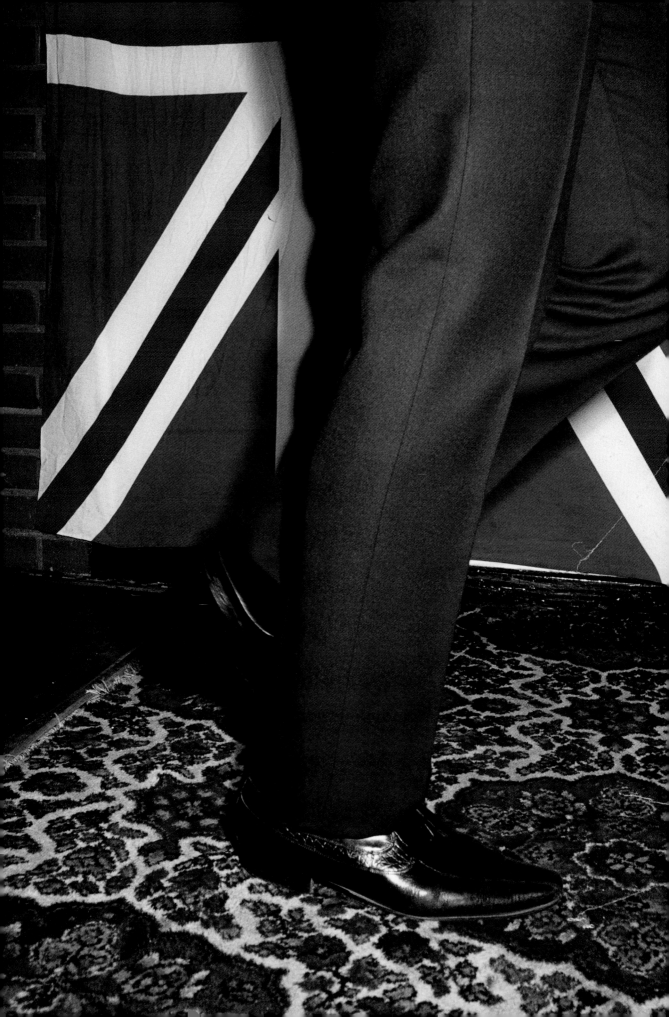

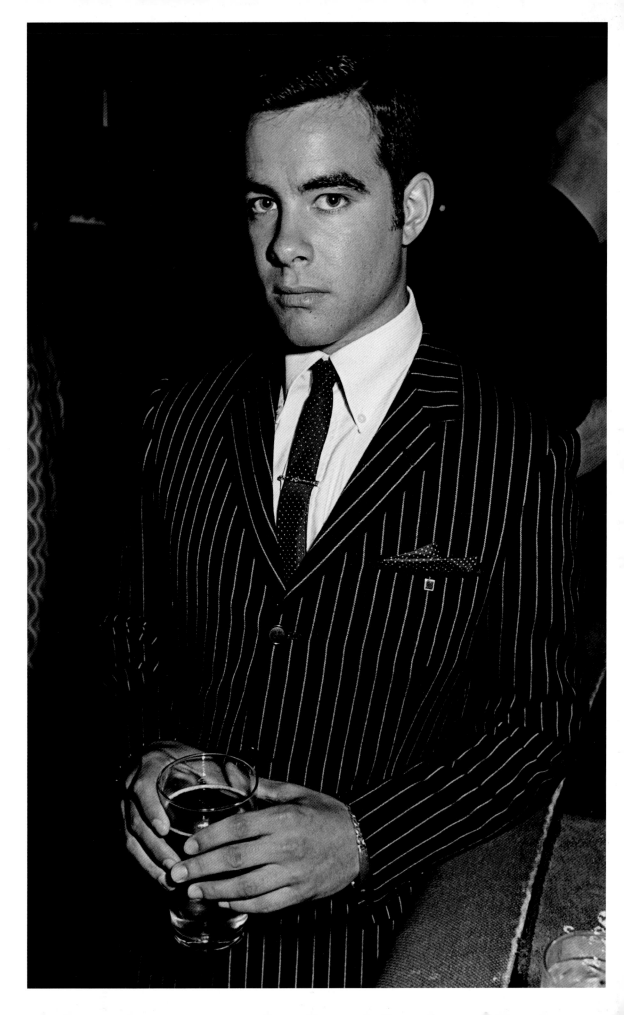

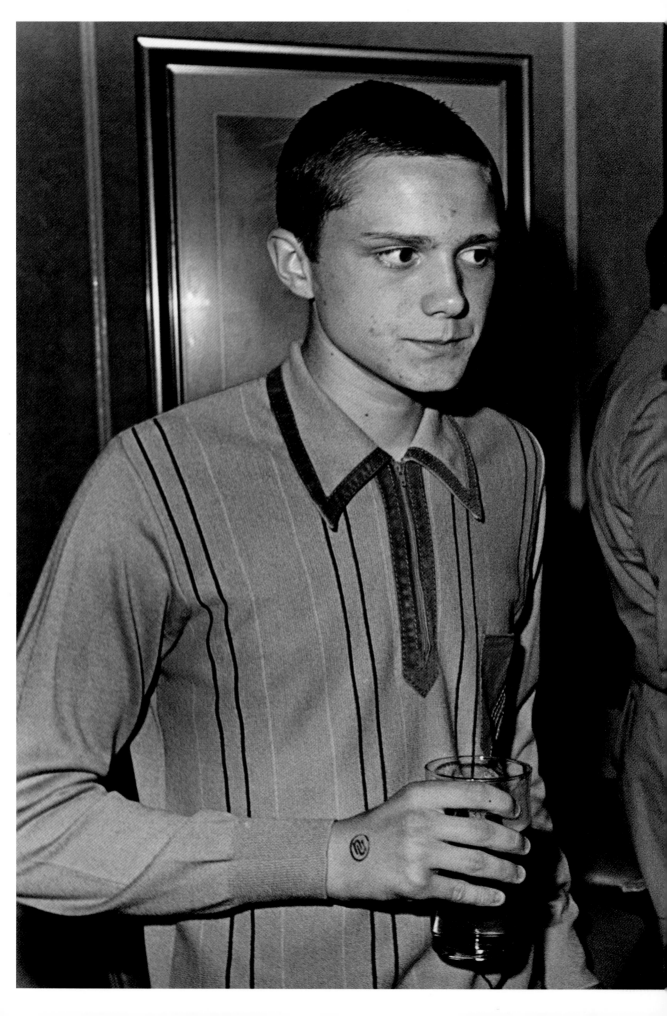

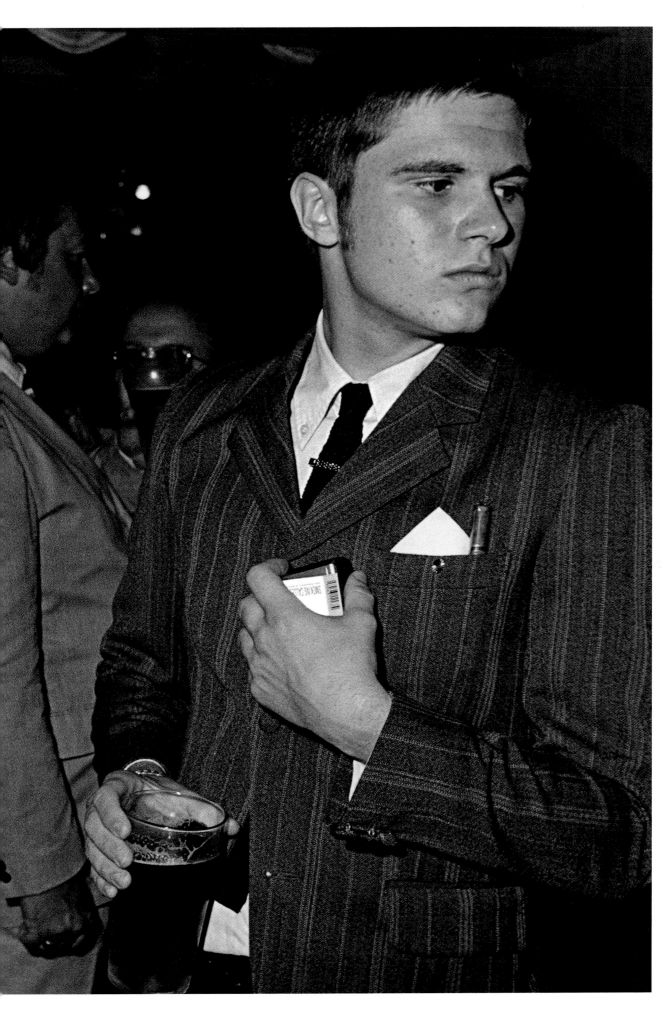

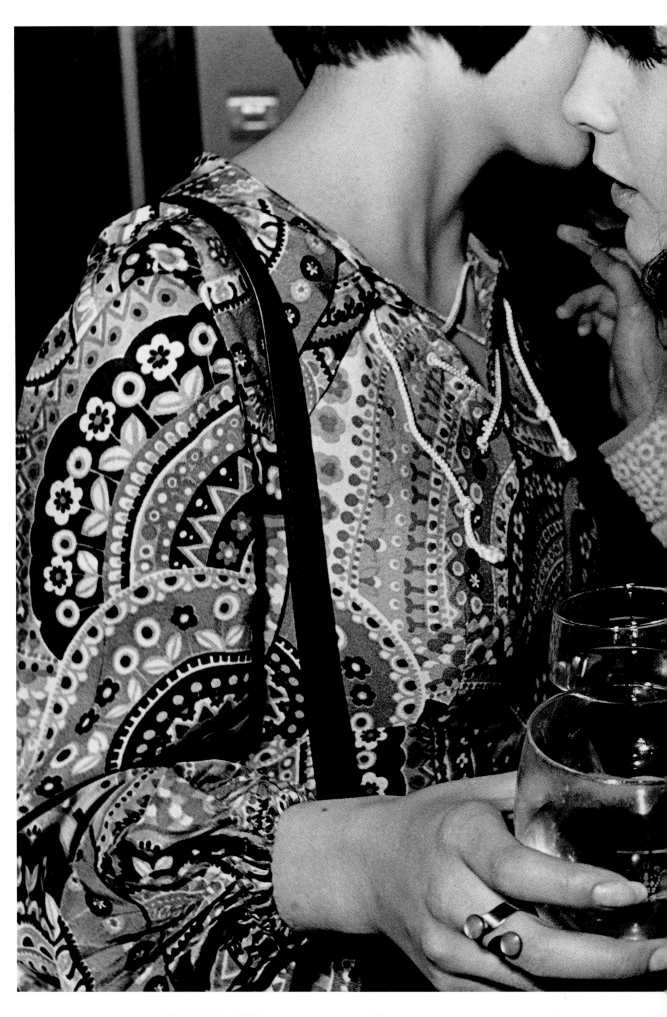

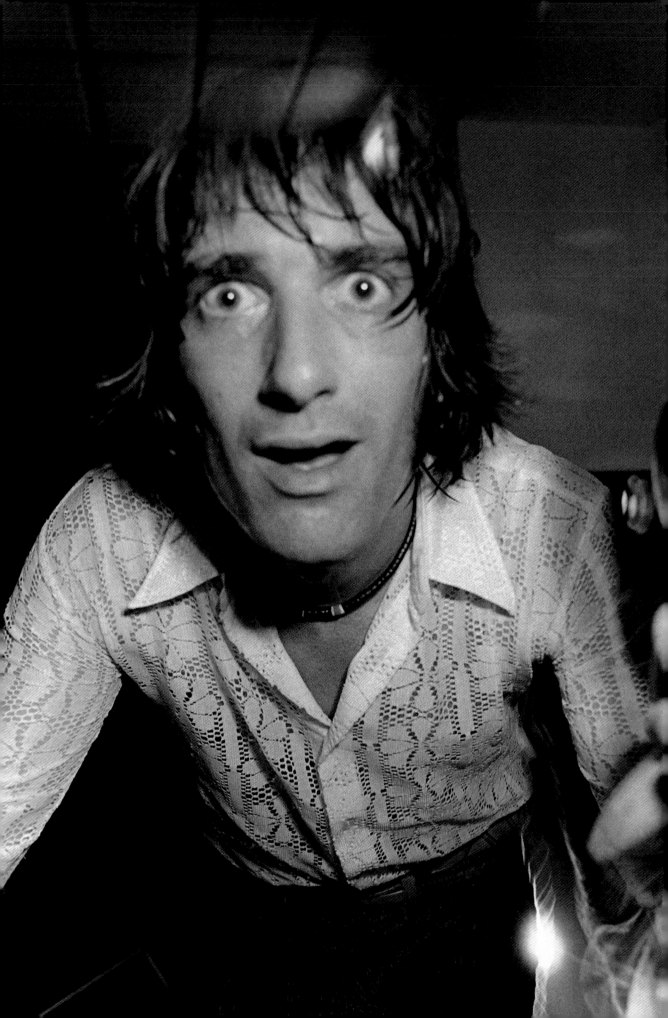

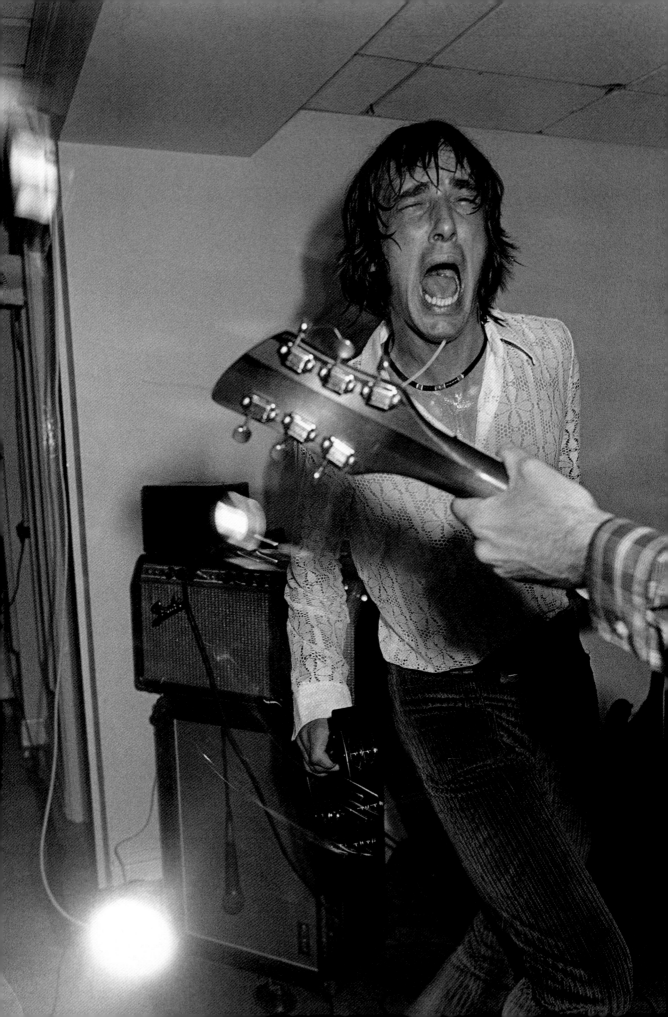

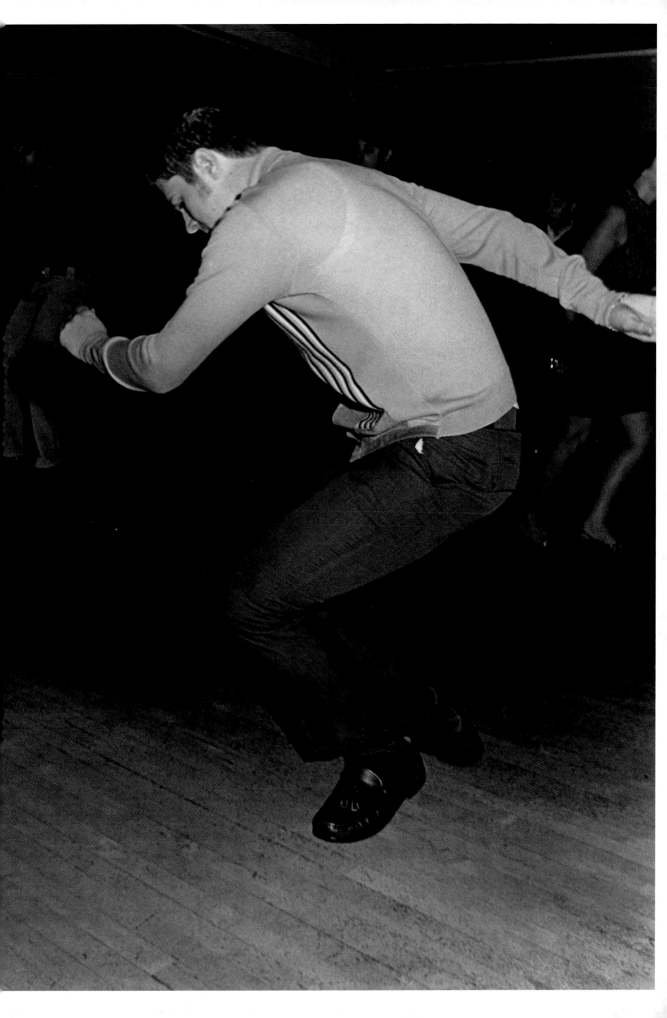

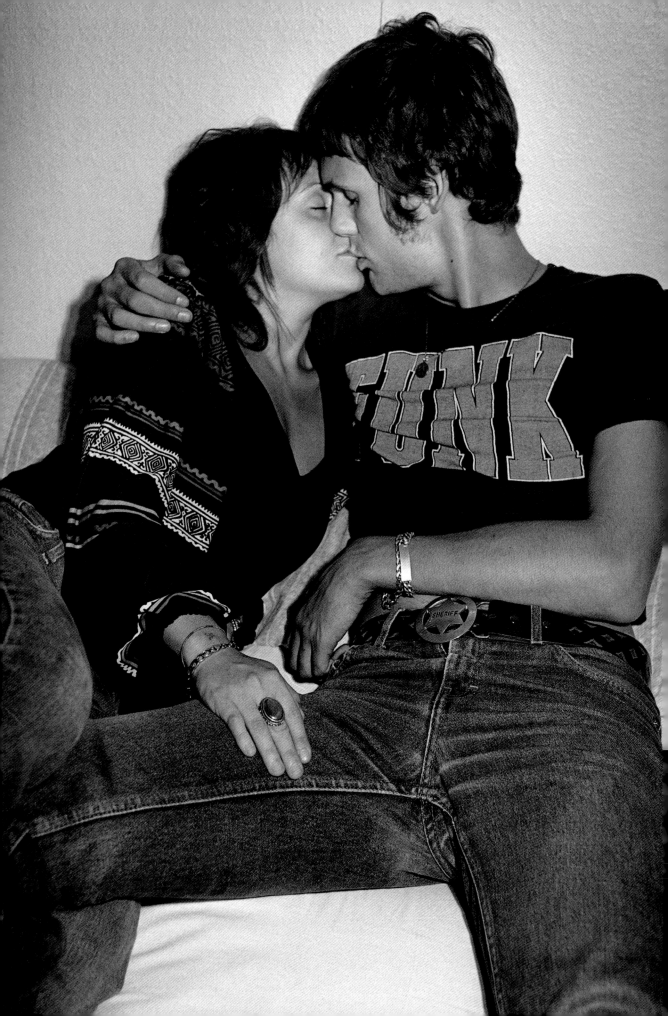

MY PERFECT PARTNER,
MY SOUL MATE IN EVERY SENSE OF
THE WORD. SOMEONE WHO LOVES
AND RESPECTS ME FOR WHO I AM,
SOMEONE WHO SHARES MY PASSION
FOR 60'S MUSIC, CLOTHES, DESIGN
AND OPTIMISM, SOMEONE WHO CAN
MAKE ME LAUGH AND LIKES
TO HAVE FUN!
AMY

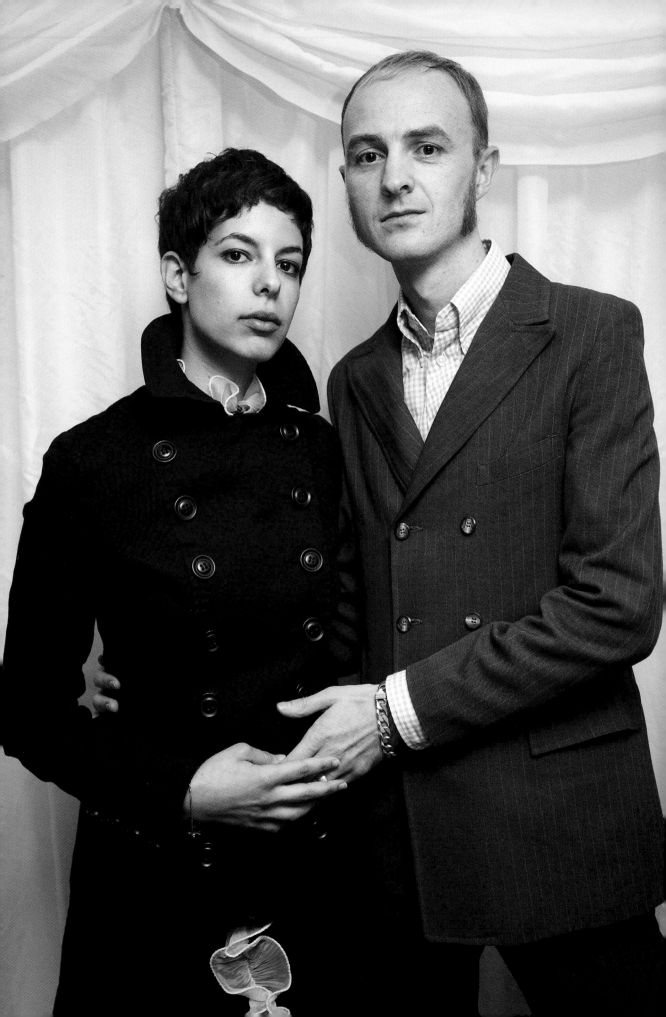

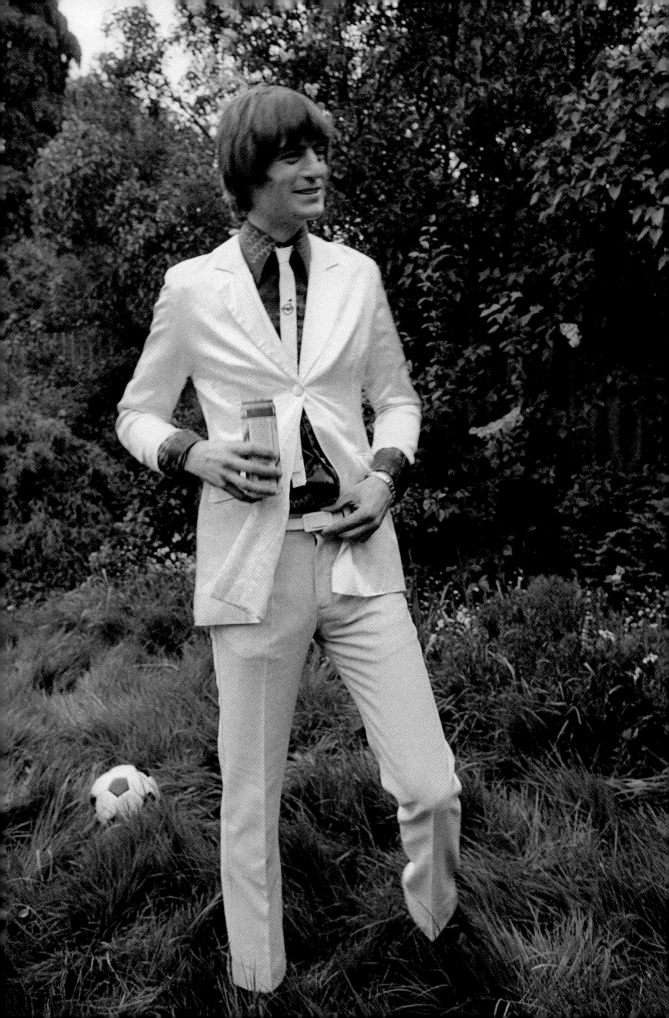

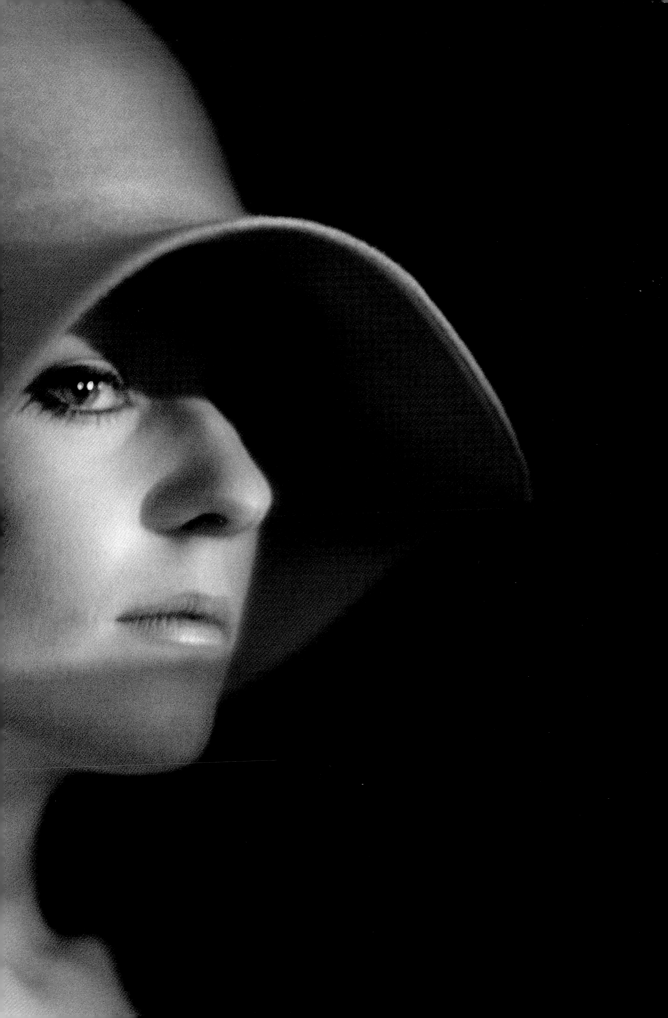

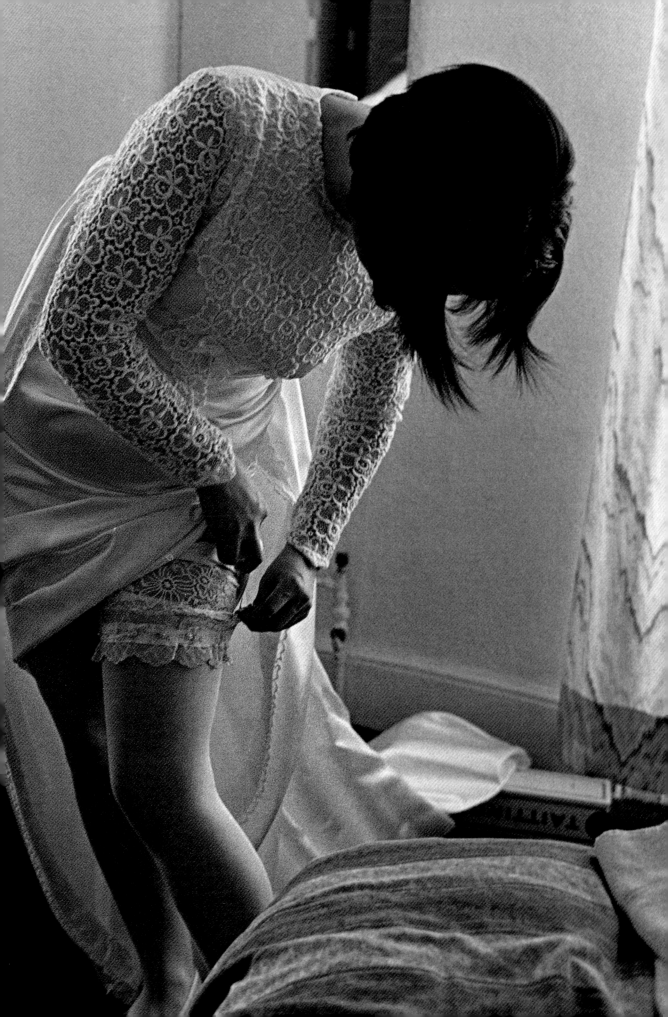

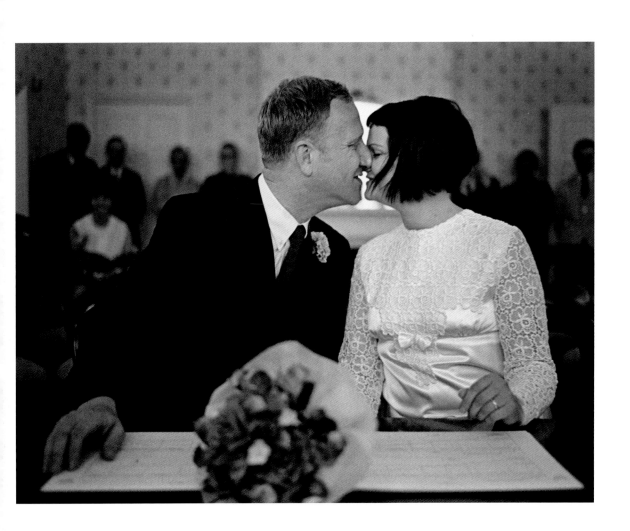

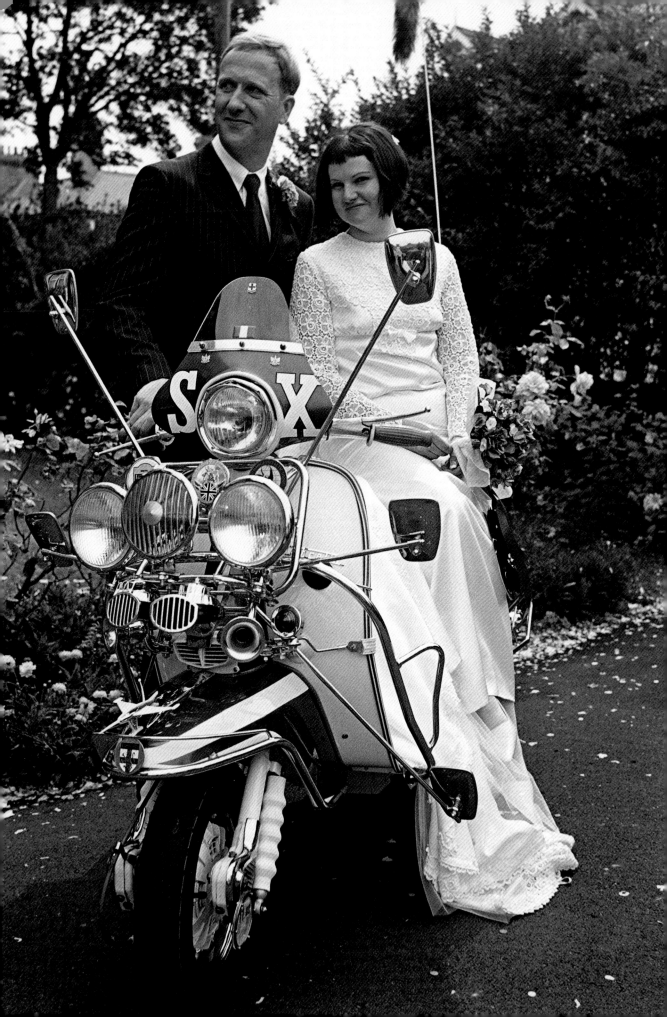

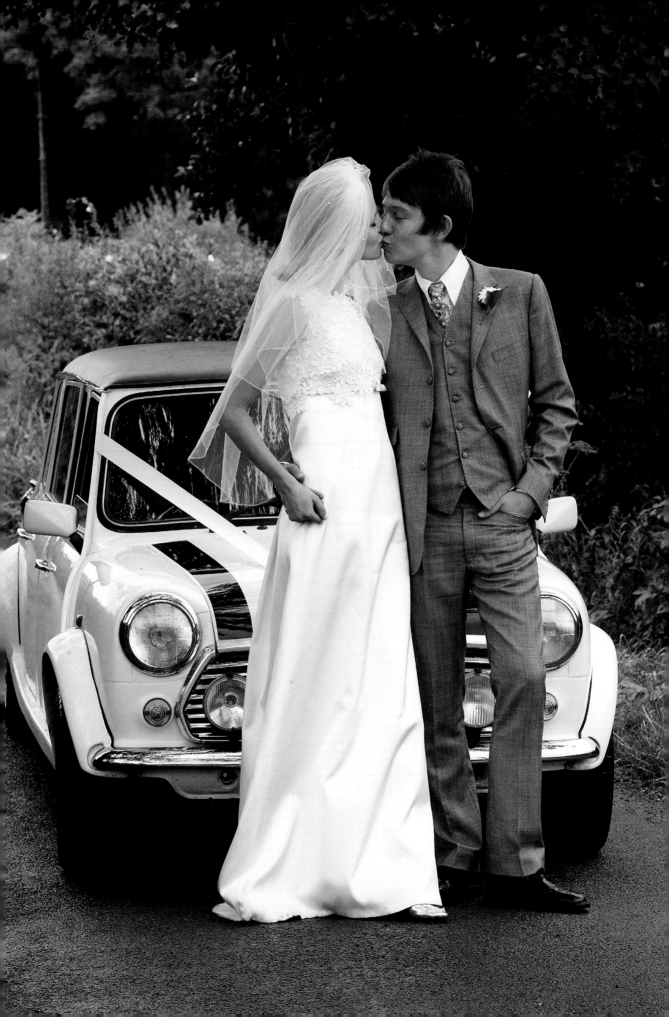

I LIKE A MAN IN TIGHT TROUSERS, CRAVATS, PAISLEY SHIRTS, SUITS, CUBAN HEELED CHELSEA BOOTS AND MOST OF ALL SIDEBURNS AND A GREAT HAIRCUT – ITS ALL ABOUT THE HAIR!

ELLIE

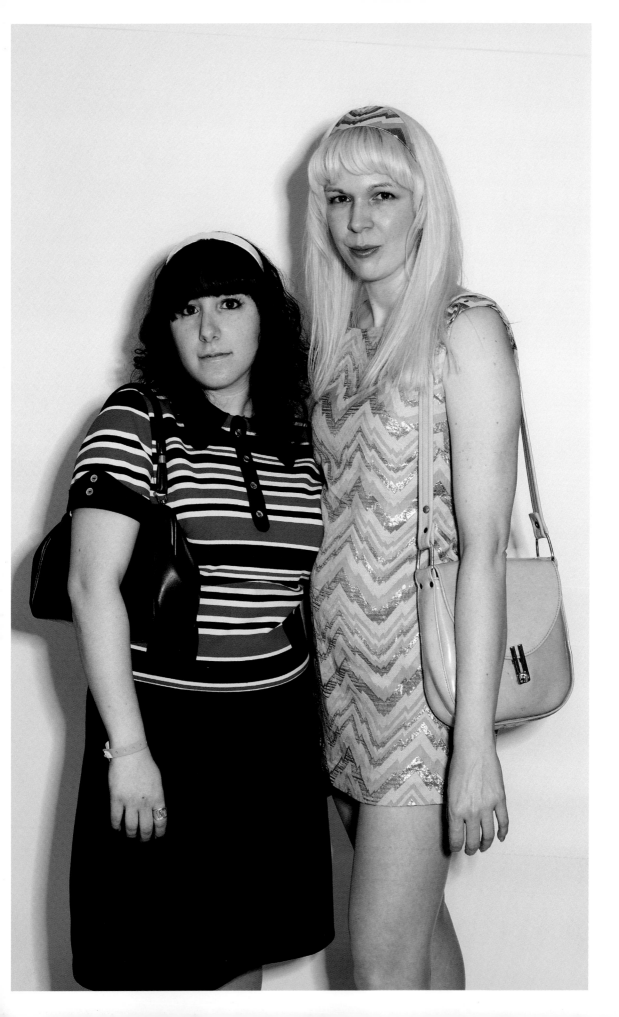

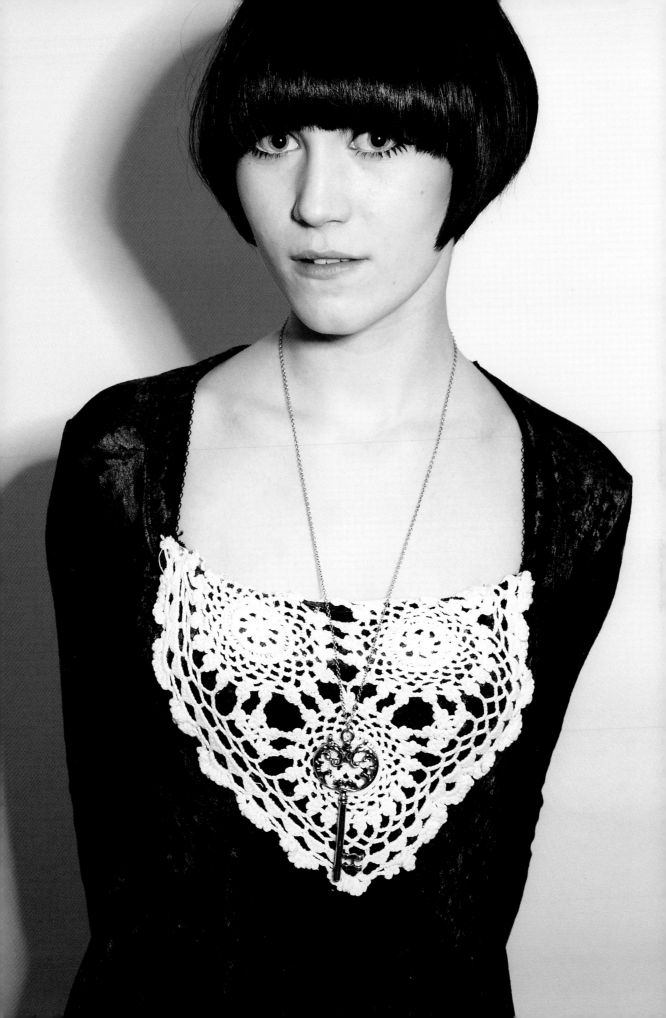

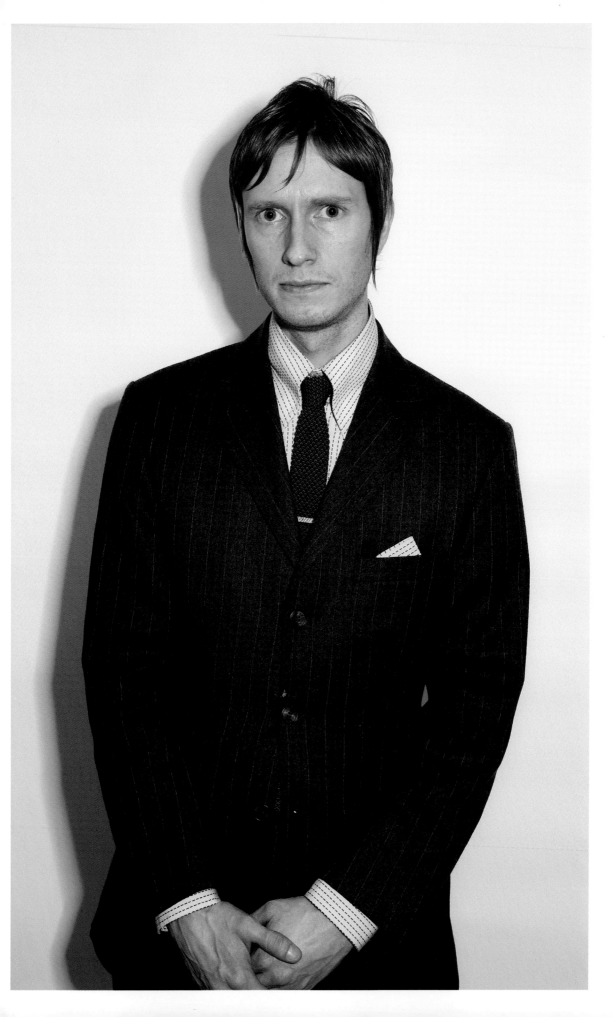

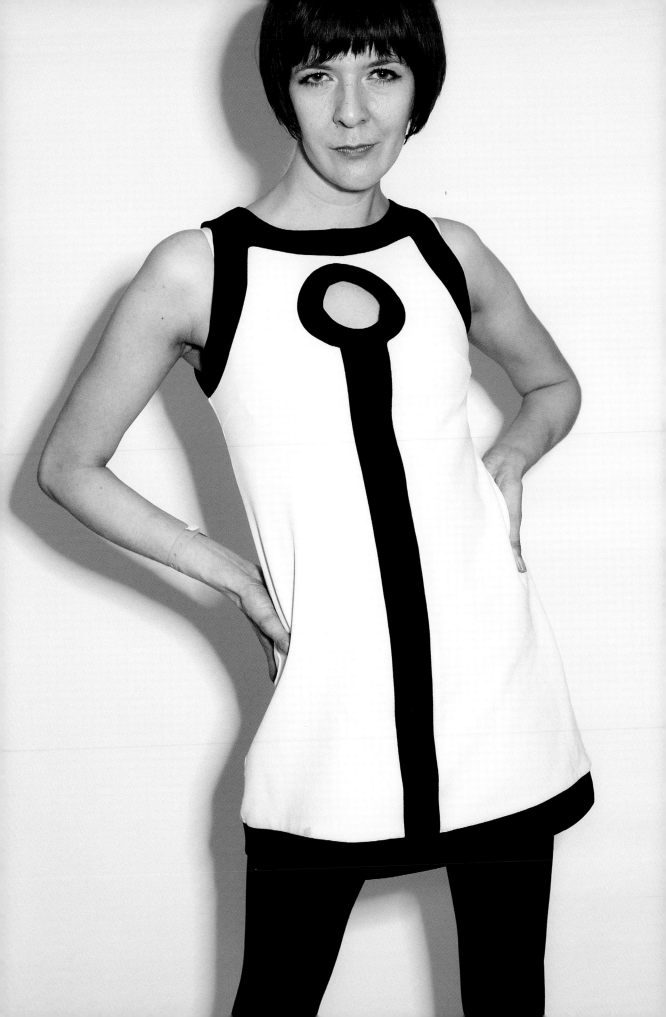

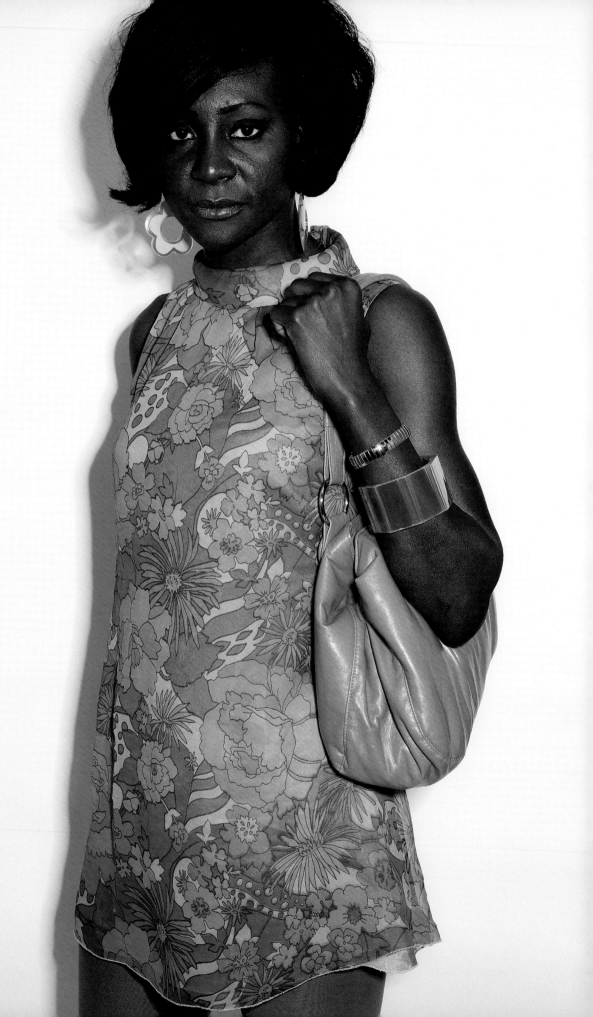

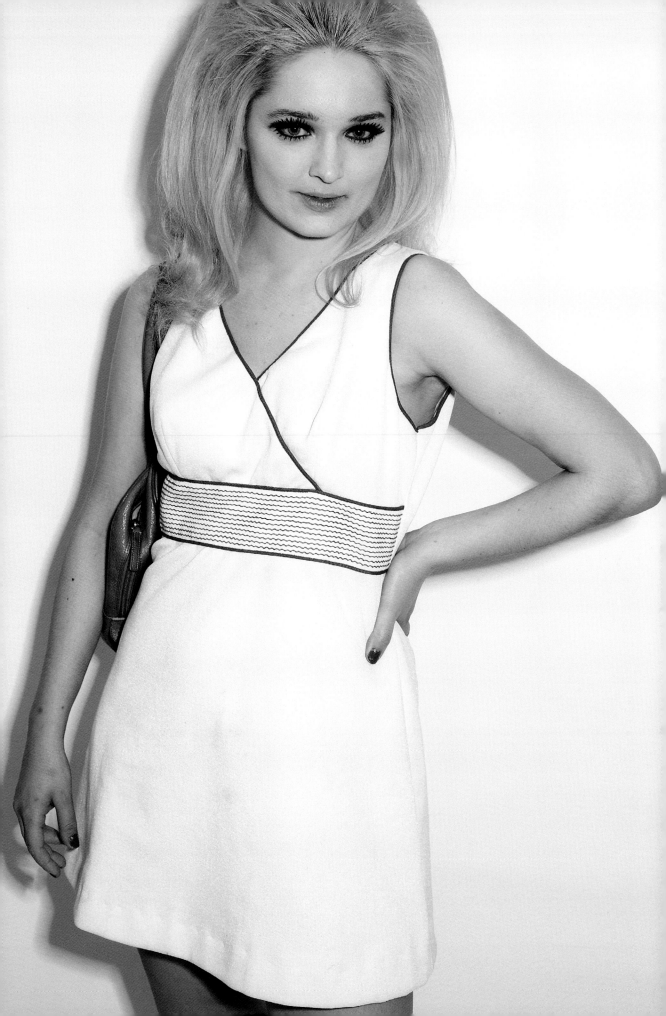

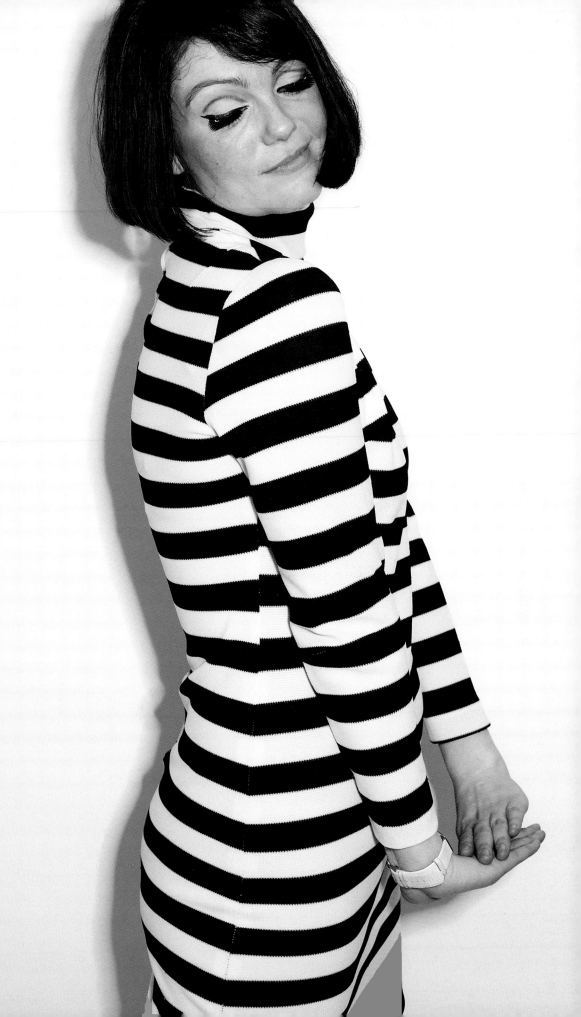

IT'S A BROAD CHURCH
OF MUSIC AND STYLE
SPANNING THE LAST FIVE DECADES.
EACH GENERATION ADDS
ITS OWN INGREDIENT
TO THE MELTING POT
KNOWN AS MOD!
ROB

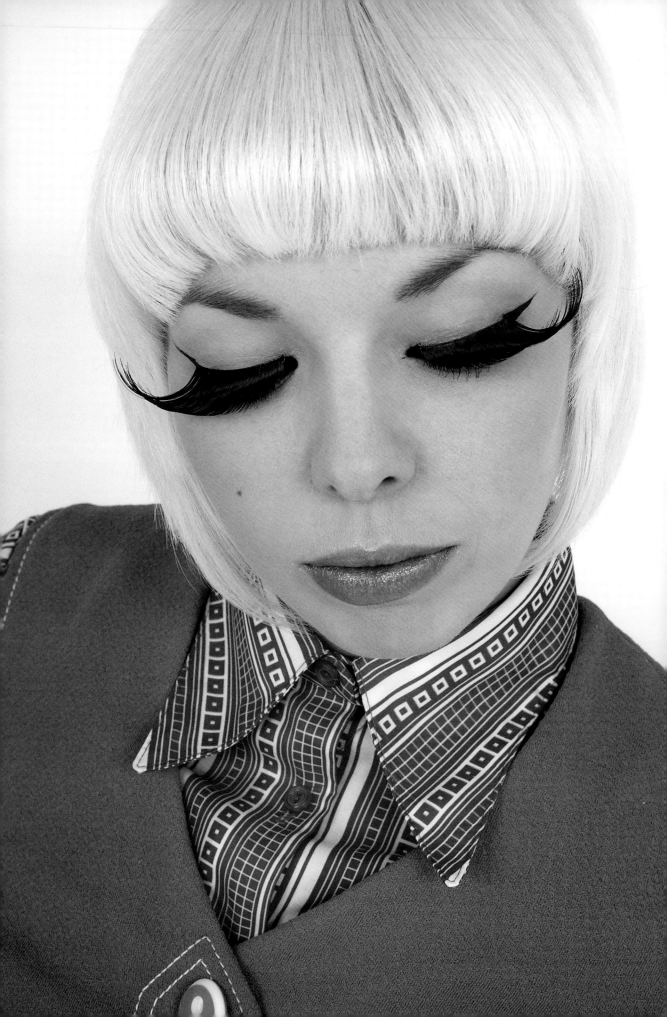

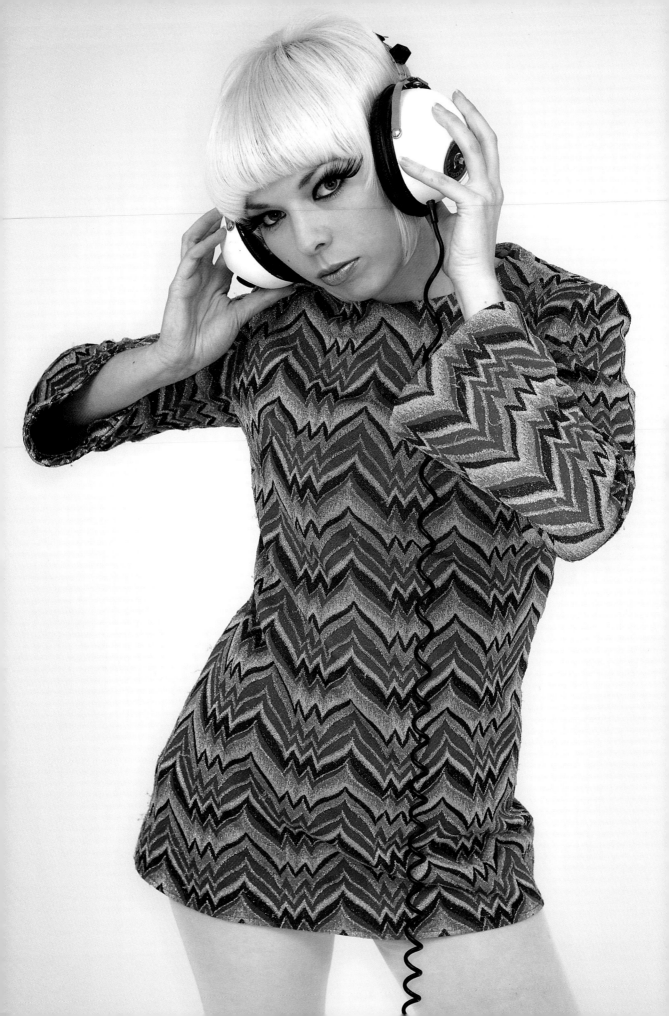

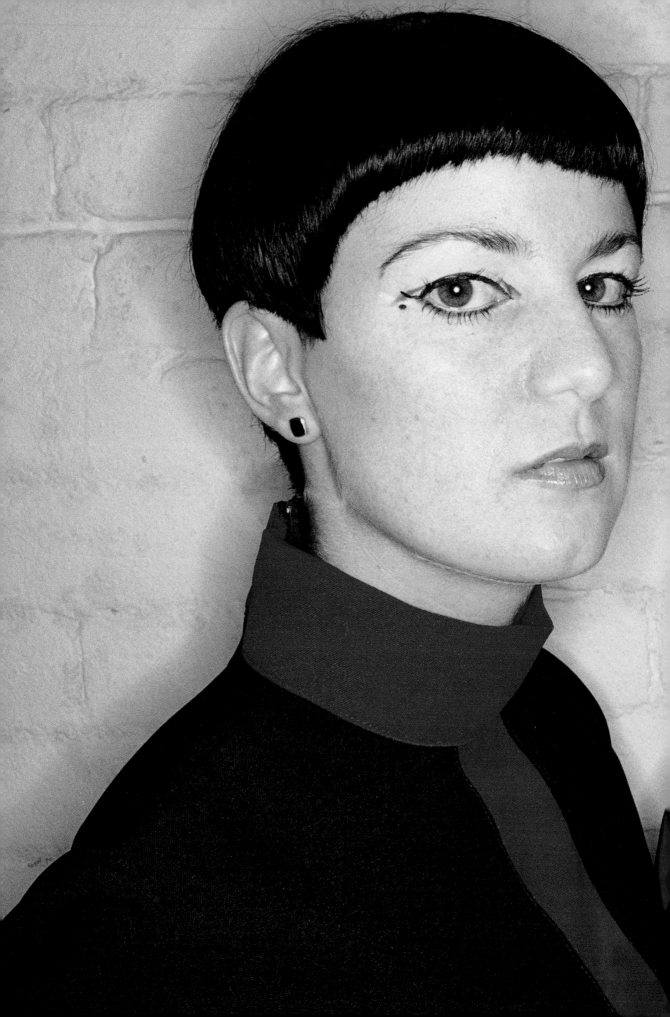

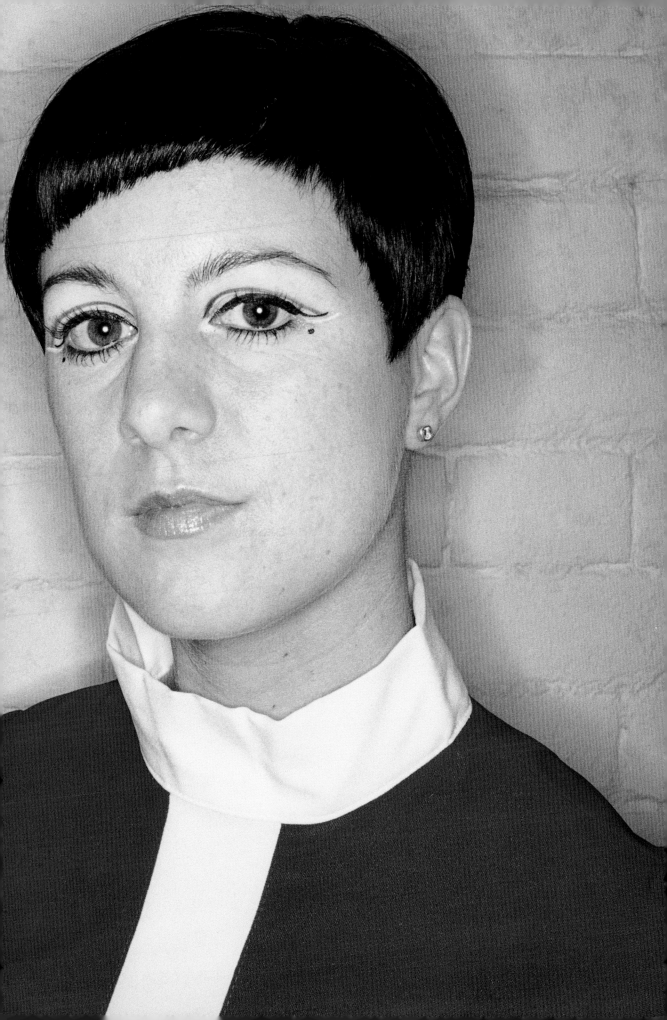

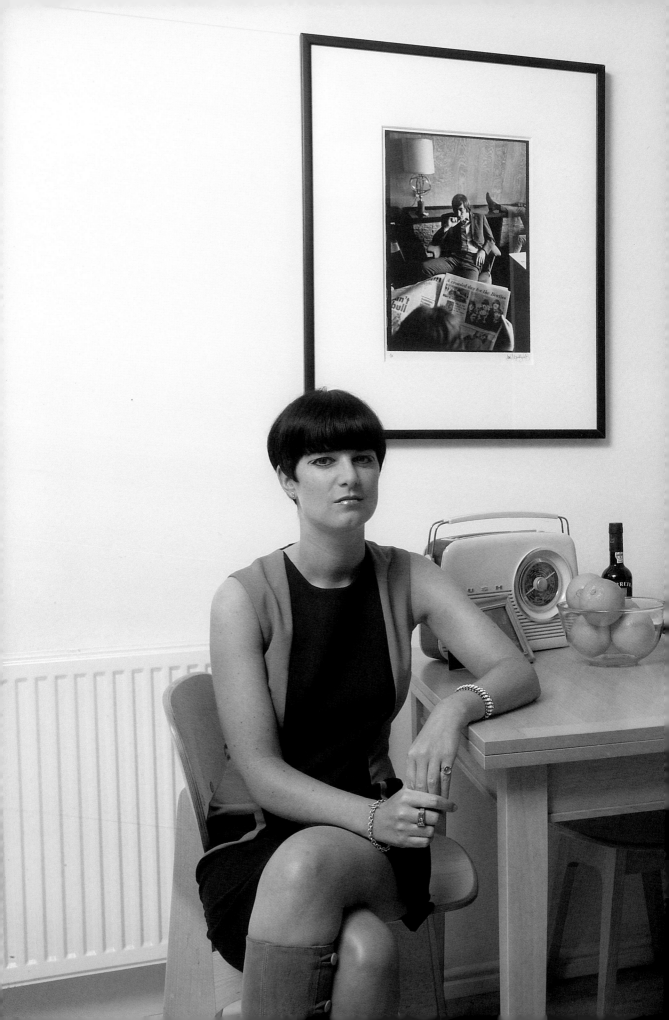

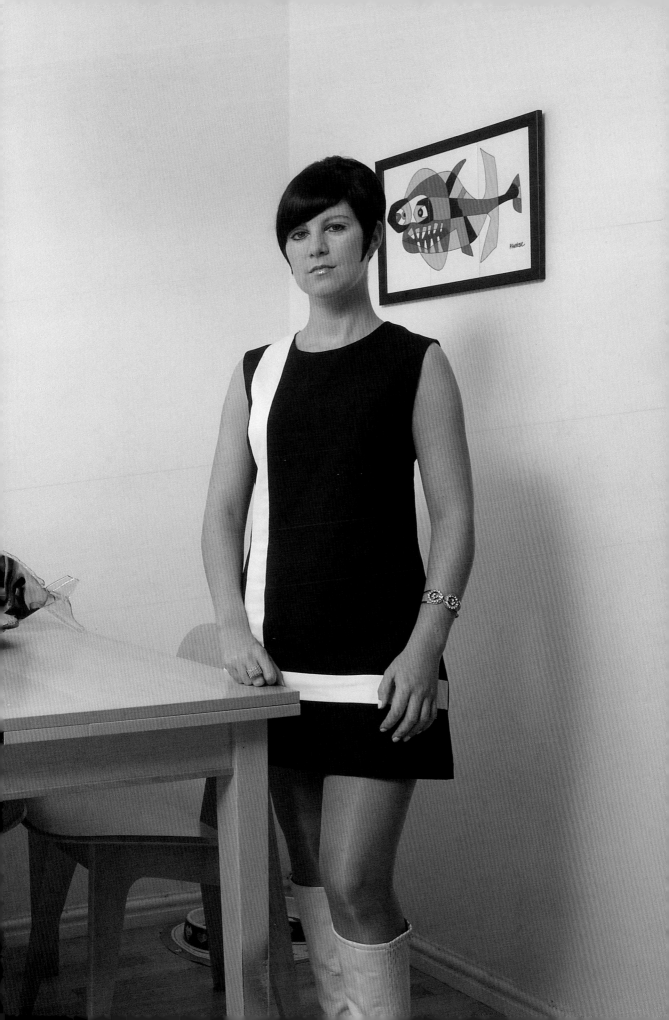

01

02

03

04

05

06

07

08

09

10

11

12

13

14

15

16

17

18

19

20

21

22

23

24

25

26

27

28

29

30

31

32

33

34

35

36

37

38

39

40

41

42

43

44

45

46

47

48

49

50

51

52

53

54

55

56

57

58

59

60

61

62

63

64

65

66

67

68

PICTURE CAPTIONS
21ST CENTURY MODS

01 Pihl and Steph, London, 2001
02 Angie doing her make-up, Clacton-on-Sea, 2003
03 < Angie at modernist fashion show, London, 2004
 > Sean, Modstock, London, 2004
04 Leyra, Weston-super-Mare, 2002
05 Paul, dressed as actor Michael Caine,
 Scarborough, 1998
06 < Young couple, Birmingham, 2004
 > Rob Bailey (NUTS), Brighton, 2001
07 < Ellie, London, 2008
 > Scott, London, 2009
08 < Alex and Beth, Southgate, 2006
 > Alex, Brighton, 2007
09 < Chloe, riverboat party, London, 2002
 > Mikki, London, 2006
10 Elliot, Clacton-on-Sea, 2003
11 Lambretta scooter, London, 2005
12 Teddy, scooter surgery, London, 2008
13 < Scooter surgery, London, 2008
 > Teddy posing with his Lambretta, London, 2008
14 < Beth and Alex, Brighton, 2008
 > Buckingham Palace scooter run, 2005
15 < Amy and Graeme, Hastings, 2001
 > Alan & Kolla, London, 2005
16 < Steve & Liz, Hastings, 2001
 > Graeme & Amy, Margate, 2004
17 Scooter cruise, London, 2005
18 Scooter cruise, Scarborough, 1998
19 Weston-super-Mare, Easter Bank Holiday, 2002
20 May Bank Holiday, Scarborough, 2002
21 < Imogen, Brighton, 2008
 > Chrome scooter, Bank Holiday, Margate, 2004
22 < Man repairing scooter, Scarborough, 1998
 > DJ Paul Sawtell, Scarborough, 2006
23 < Spider Mod weekend, Margate, 2002
 > Mod weekend, Hastings, 2001
24 < Mod couple, London weekend, 2001
 > Scott, Brighton, 2008
25 Scooter competition winners, Brighton, 2008
26 < Mods gather on Seafront, Brighton, 2008
 > Scooter competition, Brighton, 2008
27 Scooter cruise, Scarborough, Weston-super-Mare
 and Hastings, 1998-2002
28 Roaring into town, Hastings, 2002
29 Laura & Sarah, Brighton Mod weekend, 2008
30 < Rachel, Clacton-on-Sea, 2003
 > Matt and Georgia, Brighton, 2008
31 Birmingham Mod Weekender, 2004
32 Getting ready for rideout, London Weekender, 2002
33 < Jarvis Humby, Scarborough, 1998
 > Graham & Sharon, Weston-super-Mare, 2002
34 Swedish couple, Margate, 2004
35 < Emily & Rachel, Margate, 2004
 > Simon, Clacton-on-Sea, 2003

36 < Mod weekend, Margate, 2002
 > Morning after Allnighter, Margate, 2002
37 Melanie, Margate, 2004
38 Phil and Jo, Weston-super-Mare, 2002
39 Rhys, Steph, Jack, Long John, Clacton-on-Sea, 2003
40 < Niamh Lynch, LBB4 Party, London, 2008
 > Steph dancing at Mod weekend, Brighton, 1998
41 < Jack during dancing competition, Scarborough, 1998
 > Birgitt, Clacton-on-Sea, 2003
42 Jo dancing, Bank Holiday, Margate, 2004
43 < Mods dancing in a club, Hastings, 2004
 > Shopping for records, Brighton Weekender, 2008
44 < Two young Mods at LBB4 Party, London, 2008
 > Jo dancing, Margate, 2004
45 François dancing at London Allnighter, 2008
46 Amelie, Clacton-on-Sea, 2003
47 < Scott at LBB 4 Party, London, 2008
48 < Harry, Le Beat Bespoké 4, London, 2008
 > Coffin Joe, Brighton weekender, 2008
49 < Faris Rotter, Modstock, London, 2004
 > Amy at Weekender, Clacton-on-Sea, 2003
50 < Jack dancing behind Union Jack, Clacton-on-Sea, 2003
 > Harry, Bank Holiday, Margate, 2004
51 Brothers Daryl & Kieron, Bank Holiday, Marget, 2004
52 Leyre and Jo, Scarborough, 1998
53 Jay The Phrogs, Brighton, 1998
54 < Jay The Phrogs, Brighton, 1998
 > Dancer, Margate, 2004
55 Jack and Alessia, Scarborough, 2002
56 < Russell and Sarah, Sussex, 2007
 > Simon, London, 2004
57 Rachel, Bank Holiday, Margate, 2004
58 Mod wedding bride Dawn putting on garter,
 Margate, 2004
59 Big John and Dawn wedding, Margate, 2004
60 Amy and Graeme wedding, Sussex, 2007
61 < Lynsey and Katherine, LBB3 London, 2007
 > Rosie, LBB3 London, 2007
62 < Robert, LBB3 London, 2007
 > Natalie, LBB3 London, 2007
63 < Amma, LBB3 London, 2007
 > Malise, LBB3 London, 2007
64 Claire, LBB3 London, 2007
65 Aoife, LBB3 London, 2009
66 Twins Paula and Karen, London, 2006
67 Twins Paula and Karen, London, 2007
68 Steve and Liz, Mod weekend, Hastings, 2002

Cover: Scott, Matt, Georgia and Scott
 on their Lambrettas and Vespas, London, 2009
Back cover: Aoife dancing at Le Beat Bespoké 4,
 London, 2008

A BRIEF HISTORY OF MOD
PAOLO HEWITT

Mod has mysterious roots and rightly so. The fact that it is impossible to pinpoint one person, one date, one event to mark as its birth is how it should be for a youth cult driven by the forces of secrecy, elusiveness and subtlety. There is no clear starting point, just an observation that a series of changes, which took place in London after the Second World War, served to create the Mod ideal.

Let us start with the birth of modern jazz – the birth of the cool. Modern jazz was an American musical invention. It featured small bands playing improvised music. Its leaders had names such as Miles Davis, Stan Getz, Gerry Mulligan and Dizzy Gillespie. More importantly they dressed smartly, opting for what is known in America as the Ivy League Look, a mix of sharp suits, button-down collared shirts, knitted ties. They did not dress to draw attention to themselves, rather, the idea was that they could slip into the street unnoticed, yet their art was of the most radical kind imaginable.

In London, the modern jazz scene pitted itself against the Trad lovers. Trad boys and girls swung to the sound of 1920's New Orleans music. 'Too square,' said the Modernists, 'Too backward looking. Too damn happy. The future is now. The future is modern.' The people who said such things were jazz-men through and through, people like Ronnie Scott, Tony Crombie and Peter King. They and others rehearsed as a band in the basement of 11 Archer St. This was the late 1940s.

They played during the day and people wandering by would hear the music and venture downstairs to check it out. After a while, it made sense to charge them money to listen. Thus Club 11 was born. Their raves attracted the forward thinkers who dressed sharply with shades, took speed and danced till six in the morning, emerging weary and exhilarated into grey London streets. There's nothing new under the sun. Kids still do that today. Later on, the club moved, finally settled on Frith Street. We know it now as Ronnie Scott's.

The scent of jazz and change that was gently blowing through London caught other people's attentions. Jeffrey Kruger was a film salesman who played jazz in his spare time. The clubs he performed in were small, musty, smelling keenly of beer. Kruger looked around and thought, 'Wouldn't it be great to host a smart jazz club, where the air is clean, and the clothes are smart?'

He ate one night at the Mapleton Hotel on the corner of Wardour St and Piccadilly with this in mind and found his nirvana. It was a room downstairs on the lower floor. He made the manager an offer and the Flamingo was born. The first thing Kruger did was to charge people twice as much as any other club in London and insist his customers look the part. It proved an intelligent move. The place was rammed – a compelling mix of gangsters (the Krays were regulars) smart boys, working girls, smart girls. Every week, he hung up the sold out signs and went to bed richer than the night before.

Around this club various shops of great importance to this story operated. David's on Charing Cross Road, Austin's in Piccadilly. Both sold American clothing: smart, expensive clothes that their customers broke the bank to acquire. Another important shop was Cecil Gee's, over there on Charing Cross Road. Gee went to Italy in 1955 and came back with Italian suits and items such as coloured jumpers and snazzy tops. Gee filled his window with his Italian loot and many people came to him, excited by what they glimpsed. This included London's growing Italian community, many of whom worked the numerous Soho coffee bars. On off duty hours they would check into London cinemas such as the Academy on Oxford Street and watch Italian movies. Soon, young London kids did the same. They sat there and checked out the actors, not for their craft or interpretation of the storyline, but for their clothes, sartorial tips and ideas.

Mod fused together Europe and America in a compelling fashion. The pre-war idea that sons had to dress like their fathers was being broken in half. Another man to put the nail in that particular coffin was a young Scotsman, name of John Stephen. He came from a hard part of the world – Govan in Glasgow . He escaped for

London, a stylist, a clothes obsessive who summed up his mission in life thus: 'If I can make it so that a young man can wear a pink shirt on the street and not be called a homosexual then I will have done my job.' John Stephen did his job. He worked in Moss Bros, and then moved to Vince's on Foubert Place. Vince's was a theatrical outfitters, frequented by gays, but straight, young Modernists could sometimes be seen lurking outside, fixated maybe by a pair of lime-green socks in the window. Stephen took note, saved up his money, and opened up his own shop on nearby Beak Street. One day a fire came and burnt his shop down, so Stephen moved round the corner, onto a small dark passage, made unattractive by a huge London Electricity building. That was Carnaby Street and this is 1957. Six years later Stephen owned most of the street and was a household name. His ideas were simple, but effective: he aimed to dress young people in striking colours and patterns, making them a breed unto themselves. His shops therefore were staffed by the young with pop music blaring from inside.

The London teenage world descended on Carnaby Street and made Stephen a multi-millionaire. Money was not a problem at this point. The British economy had shifted into high gear, and hire purchase was available for all. But, the Modernists themselves soon became suspicious of Carnaby Street. They preferred a smarter look – a look that raised many questions. What worked best under a collared shirt – a T-shirt or a vest? What collar was the best one – a Brooks Brothers or a Lion and Troy? Questions such as these obsessed them, although at this point – 1958 – there were just a handful, some say twenty in all, guided by a man named Peter Sugar. His word on what they should wear that week was put on the grapevine on Thursday and realised fully on the Friday. Then pop music happened and jazz lost its footing as the young person's music. The newer Modernists turned their attention to another rich Black American style of music – R 'n' B. The changes can be seen at Jeffrey Kruger's Flamingo club. Now moved to Wardour Street, the club's house band was a multi-racial combo called Georgie Fame and the Blue Flames. So potent was their sound that they attracted black American GIs living on an army base about an hour out of town. These guys would bring their records – freshly arrived from America – to Georgie at the club. He and his band would take them away, study the music and the next week, play those songs right back to them. The best compliment Georgie can remember from this time was 'Hey man, you sound just like the record!'

The Flamingo was a daunting place, an edgy place. One night a knife fight erupted. The punishment was quick, severe. All servicemen were banned from leaving their camp. That's when the Modernists moved in. They wanted soul. That's why one of Georgie's most famous albums is called 'Rhythm and Blues at the Flamingo' and was made in 1964. Early Motown, Atlantic, Stax were making all the running now. As if to acknowledge this shift, clubs ditched jazz for soul and Modernists cut down their title to simply Mod. Mods were young and clever. They left school early, worked steady jobs in the West End and, at the weekends, as their bosses mowed Saturday lawns and read Sunday papers, Mods stuffed themselves full of speed and stayed awake for forty eight hours, taking in the clubs at night – The Scene, La Discotheque – and then browsing daytime shops for the latest, brightest and best clothing.

It was their time. The era of the teenager and television had to respond. It did so by creating a show called Ready Steady Go. The show aimed to give space to all the young bands now emerging, many of them playing R 'n' B covers and fronted by singers who prayed every night that they would wake up the next day and be Marvin Gaye or Smokey Robinson. To find music for the show, Ready Steady Go scoured the best of the London clubs for the best of the London dancers. Transmitted in 1963, RSG did something no other medium could do – it nationalised Mod. Up until this point Mod had been London exclusive. British cities were not even linked by motorways let alone a communications system. RSG showed teenagers all over Britain the latest fashions and style and the nation's youth responded by declaring themselves Mod too.

Mod made itself known at Bank Holiday weekends, when numerous kids took to seaside towns and beat up any stray rockers. In 1966, a new breed of smarter Mod emerged, wearing very sharp suits and very short hair. Hard Mods they would be called. Three years later the world knew them as skinheads. Then came the revivals, which, thanks to Rob and the New Untouchables keep Mod as strong today as it ever was. Of all the youth cults in Britain, it is Mod that has endured the longest. Goths may come and Goths may go, but Mod lasts through the years. The photographs in this book by Horst A. Friedrichs mean that the Mod legacy will live on. Forever.

HORST A. FRIEDRICHS

Horst A. Friedrichs was born in Germany in 1966 and studied at the Munich Academy of Photography. From 1990–94 he worked as a freelance photojournalist for Geo, Stern, Merian, The New York Times and the Independent Magazine. His regular journeys abroad have taken him across the world from Mali to Venezuela, Japan to Pakistan. He has been living in London since the late 1990s.

Friedrichs has been involved in the Mod scene in and about London since 1997. This has resulted in thousands of interviews and photographs, some of which are shown in this book for the first time. More recently he has begun filming a series of interviews and events intended to give Mods more prominence.

ACKNOWLEDGMENTS
HORST A. FRIEDRICHS

I would like to take this opportunity to thank everyone who took part in this project: Alessia, Angie Smith, Alex and Beth, Carolina, Pid, Lee Miller, Speed, Jack White, Roger Banks, Mary Boogaloo, Paul Owers, Barry and Denise at Pip! Pip!, Jayne, Paula and Karen, Big Jon, Dawn, Dickie, Doug Bannon, Steve Garland, Ellie, Carla, Dani, Charlie, James Q, Casper, Phil Lawson, Steph, Rhys Webb, The Horrors, The Phrogs, Jarvis Humby, Rachel & Emily, Stewart, Mikki, Amy and Graeme, Matt and Georgia, Amma, Jo, Natalie, Rosie, Aoife, Lynsey, Katherine, Malise, Claire Russell, Birgitt, Niamh, Francois, Scott and Becky; Teddy Hasard, Jason Rainbird and my wife Adriana, who always listens, laughs, inspires, criticizes and supports my ideas.

I would like to express particular gratitude to Rob Bailey (The New Untouchables) who has inspired and supported me throughout the years. I am more than grateful to Lars Harmsen, who designed this book, and Tanja Rastätter from MAGMA Brand Design. Thank you to my publisher at Prestel, Jürgen Krieger, along with Curt Holtz, Andrew Hansen, Anna Kenning, Nele Krüger, Claudia Schwind, Pia Werner, Olli Barter, Renate Ullersperger and Katharina Haderer. A special thanks to my agent, Regina Anzenberger and her team who have always supported my ideas and projects.

ROB BAILEY

I would like to take this opportunity to thank everyone who has been involved down the years helping out and apologies to anyone I may have forgotten: Jason Ringgold, Paul Owers, Doug Bannon, Steve Walsh, Walshie, Mary Boogaloo, Horst A. Friedrichs, James Quinlan, Big Jon, Dickie Lewellyn, Barry & Denise at Pip! Pip! for the new website and total brand design, Jack White, Roberto Russo, Angie Smith, Stevie Bowstead, Ellie Eames and Carla Alvardo. The bands and DJ's who provide the NUTs soundtrack. All those who stuffed thousands of newsletters in envelopes, Jayne Pountain, Clara, Karin Johansson, and anyone else that has assisted over the years, you are all stars.

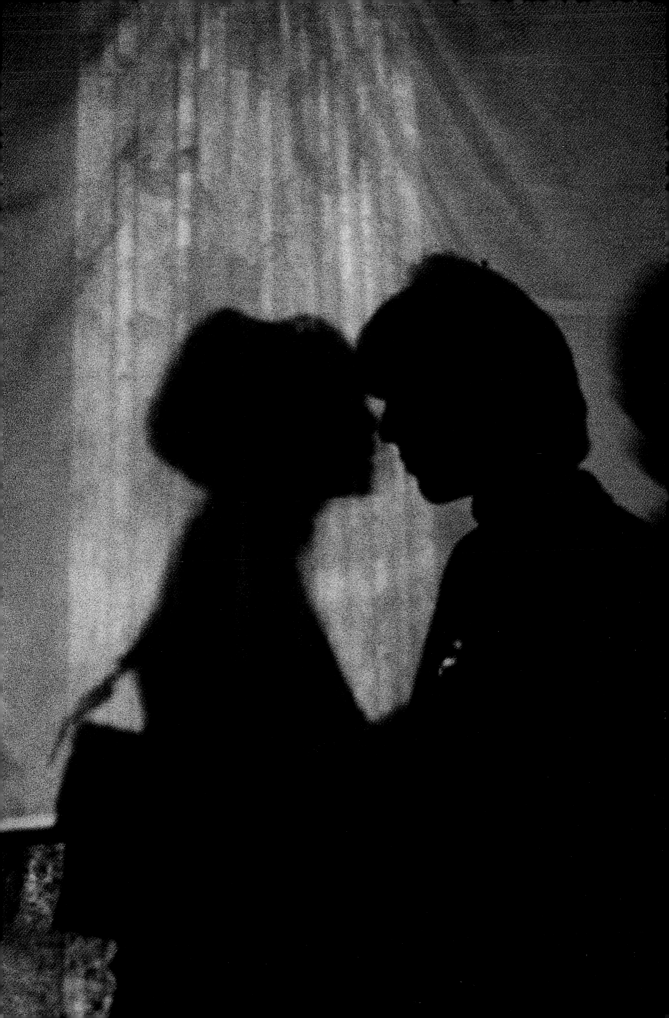

Prestel, Verlag, Munich
A member of Verlagsgruppe Random House GmbH

Prestel Verlag
Neumarkter Str. 28
81673 Munich
Tel. +49 (0)89 4136-0
Fax +49 (0)89 4136-2335

Prestel Publishing Ltd.
4 Bloomsbury Place
London WC1A 2QA
Tel. +44 (0)20 7323-5004
Fax +44 (0)20 7636-8004

Prestel Publishing
900 Broadway, Suite 603
New York, N.Y. 10003
Tel. +1 (212) 995-2720
Fax +1 (212) 995-2733

www.prestel.com

Prestel books are available worldwide. Please contact your nearest bookseller or one of the above addresses
for information concerning your local distributor.

Library of Congress Control Number: 2009927196

British Library Cataloguing-in-Publication Data: a catalogue record for this book is available from the British Library.
The Deutsche Bibliothek holds a record of this publication in the Deutsche Nationalbibliografie; detailed bibliographical
data can be found under: http://dnb.de

Editorial direction by Curt Holtz
Design and layout by Magma Brand Design, Karlsruhe
Origination by Reproline Genceller, Munich
Printed and bound by C&C Joint Printing Co., Ltd.

Verlagsgruppe Random House FSC-DEU-0100
The FSC®-certified paper *Chinese Golden Sun* is produced by mill
Yanzhou Tianzhang Paper Industry Co., Ltd., China

ISBN 978-3-7913-4820-9